People

CELEBRATES

General Hospital

50 Years

OF LOVE IN THE AFTERNOON

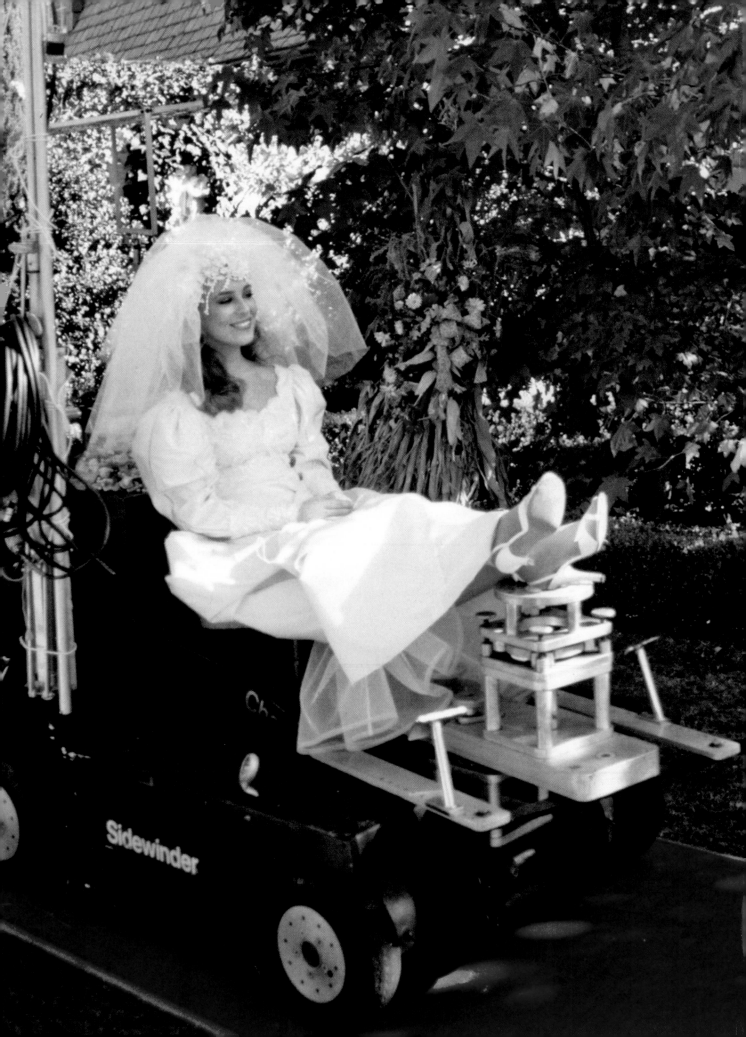

(Contents)

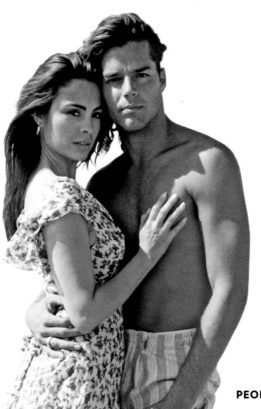

PORT CHARLES

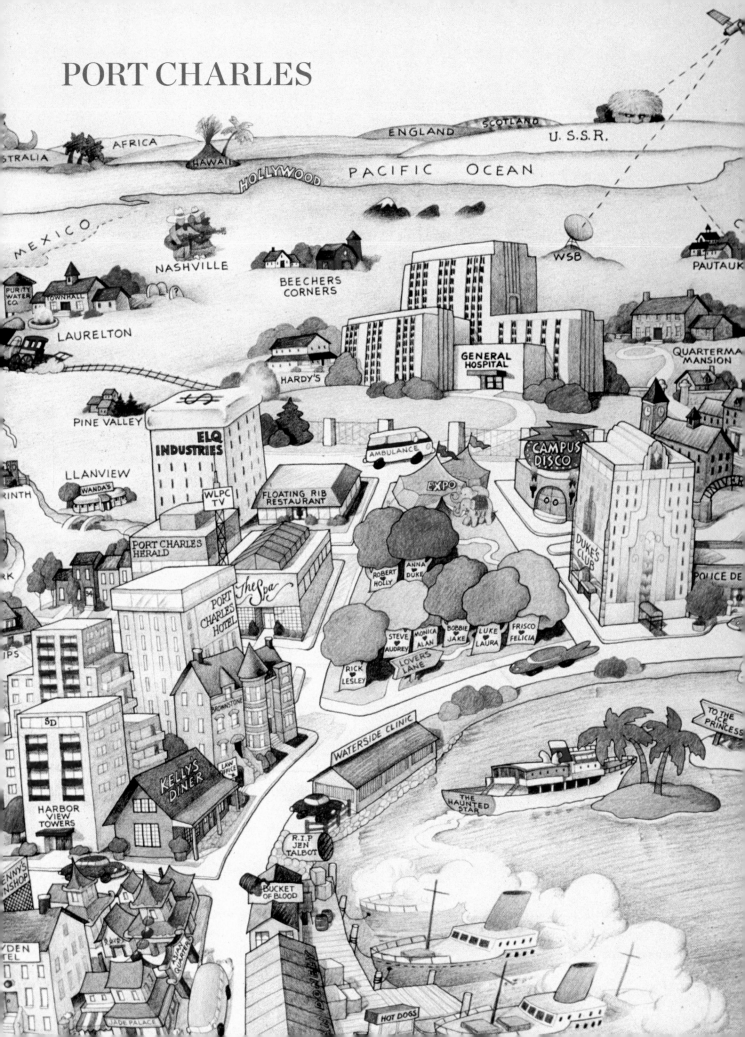

Fifty Years? OMG!

There's always something new to discover about Port Charles (left, a fanciful map from 1995): Over the years it has been revealed to have an Asian Quarter, a cliffside castle on a nearby island and catacombs.

In 1960, at the height of the space race, ABC launched an astronaut-themed serial, *The Clear Horizon*, but it quickly crashed to Earth. Later that year another soap, *Road to Reality*, imploded even faster. For their third attempt, the network, inspired in part by the prime-time medical hit *Ben Casey*, dreamed up a daytime drama called *General Hospital*—and hit the jackpot (though how big a jackpot wouldn't become clear for more than a decade).

Since *General Hospital*'s April 1, 1963 premiere, America has had 10 Presidents, a moon landing, a Disco Era, a Me Decade and at least a couple of stock market crashes; seen the invention of home computers, the Internet, ATMs and Honey Boo Boo (and said goodbye to vinyl records, slide rules, black-and-white television and New Coke); watched hard rock and hair metal come and go; and been hooked on, and bid adieu to, *All in the Family, Dallas, The Mary Tyler Moore Show, M*A*S*H, Friends* and *Seinfeld* and a dozen other TV milestones. Through it all, every weekday, for more than 12,700 episodes, *General Hospital* carries on.

It hasn't been easy, particularly for the characters. The show's fictional hometown, Port Charles, is— how to put this?—not an *easy* place to live. If you want peace and quiet, try Mayberry. Over the years, Port Charles has survived hurricanes; an earthquake; an outbreak of Lassa fever; a deadly pathogen released into the water supply by Jerry Jacks; and a serial killer or two. The local hotel has been destroyed by fire, and by an explosion. For a while, things got *really* crazy: Some nut tried to freeze Port Charles into a block of ice; everyone went mad for Aztec treasure; and an alien named Casey stopped by from the planet Lumina.

In between catastrophes, its citizens seem to suffer life-threatening illness and injury at an alarming rate. When they're healthy, they hop into bed with each other, or scheme to do so, a *lot*. And, every once in a while, they throw a really *great* wedding. Worth noting: Port Charles denizens have an unnerving habit of returning from the dead. Rarely does an avalanche, a plane crash or an exploding boat keep them down for long.

Of course, it's not just the plots but the characters themselves, and the actors who play them—more than 1,800 over the years—who keep fans tuning in. For all of its problems, Port Charles is a town of astonishingly good-looking people, who lead amazingly adventurous lives. From Dr. Steve Hardy and Nurse Jessie; through Bobbie Spencer and the hallelujah moment of Luke and Laura; to Frisco, Scorpio, Brenda, Alexis, Maxie, Sonny and Quartermaines too numerous to mention; generations of fans have watched generations of characters live, love and survive. Yes, it's hard to *relax* in Port Charles—but if you like drama, as millions of viewers have known for five decades, it's a wonderful town.

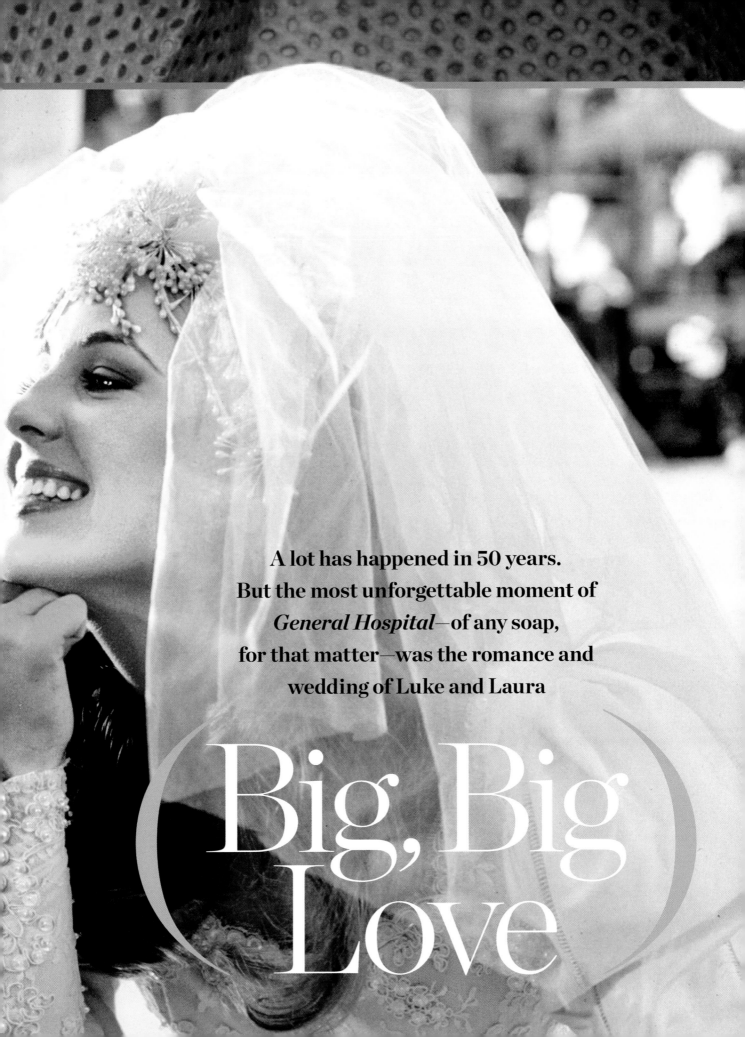

A lot has happened in 50 years.
But the most unforgettable moment of
General Hospital—of any soap,
for that matter—was the romance and
wedding of Luke and Laura

(Big, Big Love)

If you weren't there, it's hard to understand. If you *were* there, it's still hard to understand. Somehow, in 1981, a once-in-the-history-of-soaps convergence of plot, character and national appetite turned the wedding of two *General Hospital* characters, Luke and Laura, into a cultural event, and the highest-rated moment in daytime history.

How big was it? PEOPLE and *Newsweek* put Luke and Laura on the cover; 30 million people tuned in to watch their wedding; and Elizabeth Taylor, a rabid fan, volunteered to appear on the show (as a character who crashed the wedding and put a curse on the couple. "I'm wild about that show," she said. "I had a ball!"). Bars and college dorms threw viewing parties; the Kansas City Royals baseball team—who, apparently, watched in the locker room—came by the Los Angeles set for a tour. There was even a song, "General Hospi-Tale," that became a Top 40 hit.

The draw was a couple of unique characters, and plotting and pacing new to soaps. Lucas Lorenzo Spencer, played by Anthony Geary, originally appeared as a low-life front man for the mob; his role was supposed to last only a few months. Laura Webber grew up torn between her adopted and biological mothers—and that was only the beginning of her problems.

Chief among them: She had accidentally killed her older lover, David Hamilton; mom Lesley, seeking to protect her daughter, initially took the rap. Later, Laura married sweet Scotty Baldwin, and her future looked bright.

Enter Luke, and trouble. Very, very *bad* trouble: Overcome with desire, he raped Laura at his discothèque. She refused to name her attacker, however, the first hint that maybe there was more going on. Then producers, who were still planning to kill off Luke, discovered that fans were fascinated by the couple, and began turning the story into a romance. Gradually, Laura began to admit she had feelings for Luke—and that, maybe, it wasn't totally, *exactly* rape.

As head-spinning as the reversal was, fans ate it up: Geary and Francis had amazing chemistry. Interest exploded in 1980, when Luke and Laura went on the lam for the summer, providing addicts with a daily dose of adventure (searching for the Left-Handed Boy, dodging a cross-dressing hitman, getting trapped in a department store for the night, then re-creating the "Walls of Jericho" scene from *It Happened One Night* in their hotel room). Teens and college students tuned in by

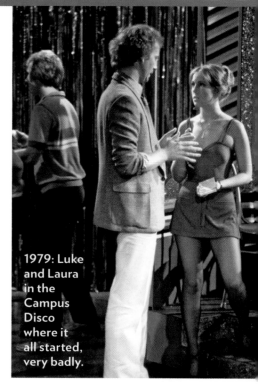

1979: Luke and Laura in the Campus Disco where it all started, very badly.

the millions—a new audience that thrilled advertisers. "I've made more friends from *GH* than from almost anything else," said a junior at Indiana University. "You walk into the TV lounge and everybody is willing to fill you in on what's going on." At the height of the craziness, Geary and other cast members made a flying visit to Harvard and

On the Run

Things really took off when Luke and Laura (in a black wig) went on the run to escape mobster Frank Smith. Adventures included (left to right) being trapped in Wyndahm's department store; hiding in a barn; and solving the riddle of the Left-Handed Boy (which turned out to be a statue). In a final shootout, Luke took a slug to the chest. When a weeping Laura thought him dead, he opened his eyes and said "Baby, what do you think you're dealing with here? You buy blue jeans, right? I bought a bulletproof vest."

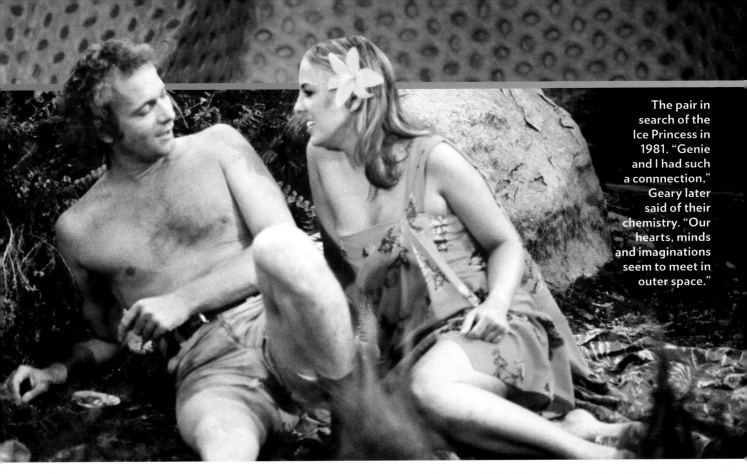

were mobbed. Said one student: "This is my one reason to get out of bed before 3 p.m."

What was the draw? "Luke's a guy with bad qualities, but he's also sensitive and romantic," Geary told *Newsweek*. "People root for him." Noted Francis, who was 14 when she first appeared on *General Hospital*, "The best way [to draw younger

viewers] was to give them one of their peers—and that was me. We did a first-love story with real-life sex, romance and heartbreak. It's every teenager's story."

By the time of the wedding— shortly after Luke had saved Laura and the world by defeating the evil plans of *GH*'s Dr. No-like Mikkos Cassadine—things were at fever

pitch. For an hour on Nov. 17, 1981, for 30 million viewers, the rest of the world stopped. Luke and Laura, surrounded by *tout* Port Charles, said "I do." Liz Taylor, as Helena Cassidine, cursed their future. And when Laura tossed her bouquet, it was caught by . . . Scotty Baldwin, her long-lost husband and the only one who could contest her quickie

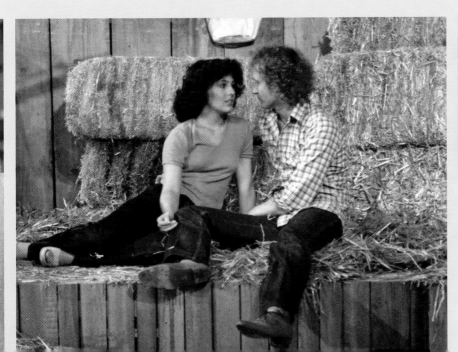

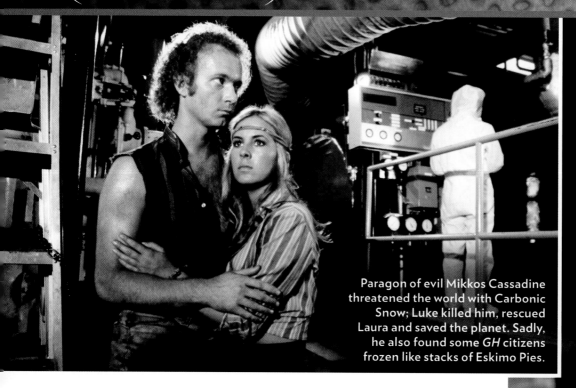

Paragon of evil Mikkos Cassadine threatened the world with Carbonic Snow; Luke killed him, rescued Laura and saved the planet. Sadly, he also found some *GH* citizens frozen like stacks of Eskimo Pies.

Mexican divorce! Luke leapt over a balcony, knocked Scotty unconscious, and the couple ran off to start a new life.

Since then, Luke and Laura have had . . . difficulties. Francis, bone-tired, left the show that year (before returning briefly in 1983). "I'm 19, I've been on since I was 14 and I'm absolutely exhausted," she said. "I've never had time for a boyfriend. I've hardly had time for girlfriends." Her character, at that point, was last seen disappearing into the fog at the end of a pier. Geary too was nearly toast. "I have given my life to this show—physically, emotionally, spiritually," he said. "Genie and I have carried as much as 60 pages of dialogue a day, four of five days a week. No nighttime show, no film makes those demands." He left in 1984. They reappeared as a couple in 1993 and dealt with their murderous nemesis, mobster Frank Smith, before Francis left again

in 2002. She returned for the couples 25th anniversary in 2006; in January, it was announced she would be back for *GH's* 50th anniversary.

Their future, however, is always a mystery. For Luke and Laura, only one thing is certain: They'll always have Port Charles, and Nov. 17, 1981.

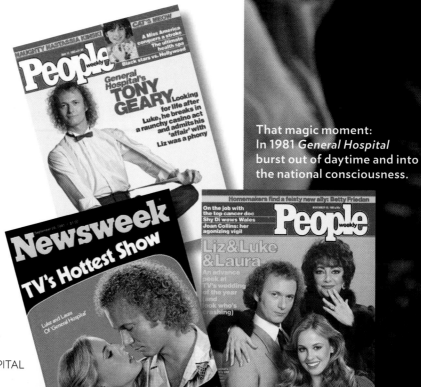

That magic moment: In 1981 *General Hospital* burst out of daytime and into the national consciousness.

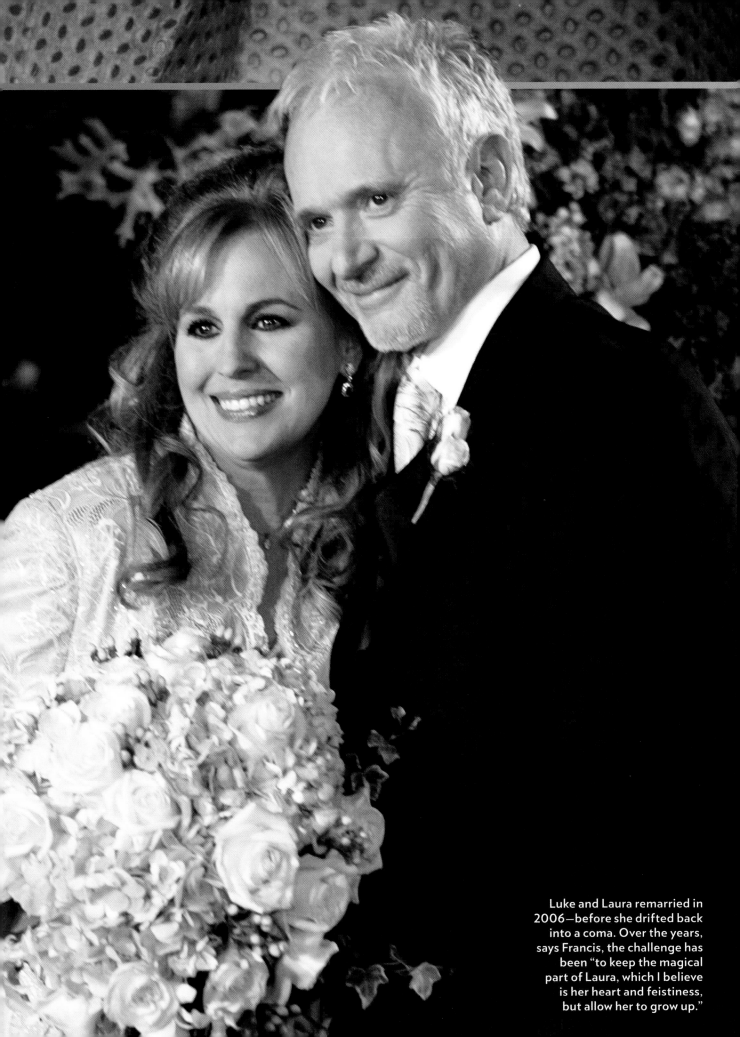

Luke and Laura remarried in 2006—before she drifted back into a coma. Over the years, says Francis, the challenge has been "to keep the magical part of Laura, which I believe is her heart and feistiness, but allow her to grow up."

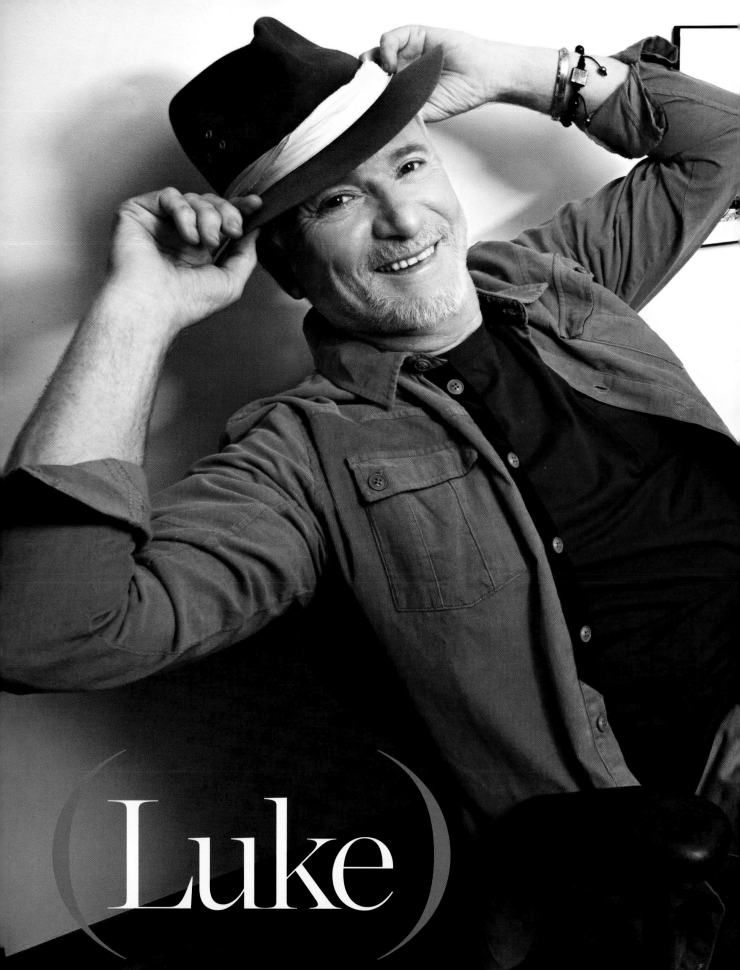

Luke

Luke in his lair: "A daytime actor is there day after day," Geary says of a soap performer's relationship to the audience. "You see them live their lives in real time as you live yours. There's an intimacy there."

In the heat of that '80s moment, being Luke Spencer, TV idol, was a wild, wild ride. Onscreen and off, Anthony Geary was the right guy for the job. On camera, his streetwise charm, full of jazzy rhythm and improvisation, kept audiences wondering what he'd do next; in interviews, the confident-unto-cocky young actor delivered the sort of quotes that made writers bless his name. "I'm a fine actor; I have abilities to communicate that are gifts," he said then. "There is no other reason for me to walk this Earth." On what he called his "not typical leading man" looks: "One critic recently said I had thin lips, a weak chin, a sallow complexion and a receding hairline," he noted. "Hey, if someone thinks that's sexy, don't take it out on me!" On comparisons to another actor then in the news: "I've been called the J.R. of daytime. Seriously, it's a nice compliment—but I want to know if people ask Larry Hagman how he feels about being the Luke Spencer of nighttime . . . Luke was alive before J.R. was alive." On Elizabeth Taylor's guest spot: "People still see daytime television as the bastard of the industry, but the fact that Elizabeth Taylor chose to come here because she's a fan must mean we're doing something right. It validated *General Hospital* for me."

At one point, intent on showing fans "you ain't seen nothing yet," he cobbled together a cabaret act, full of double entendres and bumping and grinding, and played Atlantic City. His backup singers were the Smut Queens; Geary ended the show by chanting, "Get laid tonight." "I'm outrageous in terms of what the audience expects," he said, "but I'm not as outrageous as I'd like to be."

A wild ride, indeed. Thirty-five years and seven Daytime Emmys later, Anthony Geary, 65, presents a mellower face to the world. When he left *GH* in 1984, he encountered headwinds: "I found the impact [of Luke] was such that it was difficult to do much else," he told ENTERTAINMENT WEEKLY in 2008. "I did resent it in my 30s, early 40s. But . . . I'm pretty happy to say I've come to terms with it. I'd be a bitter, nasty old man if I hadn't, and a foolish one. When you look at an actor who's been able to have a secure job for 30 years, that's such a blessing in this business." Time and talent have allowed him other perks: His contract calls for lots of time off, much of which he spends at his second home, in Amsterdam. "*GH* has never been there, and the Dutch have no sense of celebrity," Geary says. "Everything is 700 years old. There aren't a lot of cars. It's a lifestyle I love."

Is there another chapter of Luke and Laura's story to be told? Geary hopes so. "Who know's what it would be now?" he wonders. "But it can't be what it was, nor should it. It could be richer though. Maybe they could become . . . friends?"

Photograph by ALISON DYER

(Laura)

When Laura Webber finally walked down the aisle with Luke Spencer in 1981, millions, caught up in the hoopla, tuned in. But Martians could have been watching, and it still wouldn't have fully registered with Genie Francis.

"I was so young, even then," says Francis, who at 19 was five years into the role of Laura, a precocious little thing who had already killed a man, been pursued by the mob and helped save the world. "I really didn't get the Luke and Laura phenomenon, not until well into adulthood. Work was so intense, it was like being in a bubble. I have a sadness about it when I realize how big it was and I somehow missed enjoying it."

She says she won't let that happen again. In early 2013, when Francis, 50, signed on to come back for her alma mater's Golden Jubilee, she made a vow: "I'm going to enjoy every damned day of it. Every single minute! It's a nice feeling to return home."

And a familiar one. The first time Francis checked out of *Hospital*, Luke and Laura were still newlyweds; she decided there was more to life than learning lines and taping dawn-to-dusk. "I know about Genie the actress," she said then. "Maybe it's time to find out about Genie the human being."

In the years that followed, Francis worked in TV and films, then took time off, married and had two children with actor Jonathan Frakes. And she often circled back to drop anchor in Port Charles. One of Francis's *Hospital* stays, for Luke and Laura's 25th anniversary in 2006, won her an Emmy. But Laura spent much of that decade offscreen in Paris, either trapped in a catatonic state or, as Francis puts it, "learning to flip frittatas." "I had some unhappy years at the end where they really just didn't know what to do with me," she says.

This time, she's hoping to recapture some of the joy she felt in the early days of L & L. "One of my favorite times was during the story with Luke and Laura on the run in Beecher's Corners. Gloria always worked really hard to get Tony and me out of the studio by 6 p.m. each day. But one day after we'd finished taping we stayed, just lying on the bed talking. Gloria came over, very angry, and said, 'What are you doing?' We said, 'We're having so much fun we don't want to go.' She laughed. Then she got a little tear in her eye and hugged us both. There was no question in anybody's mind that we were doing something special."

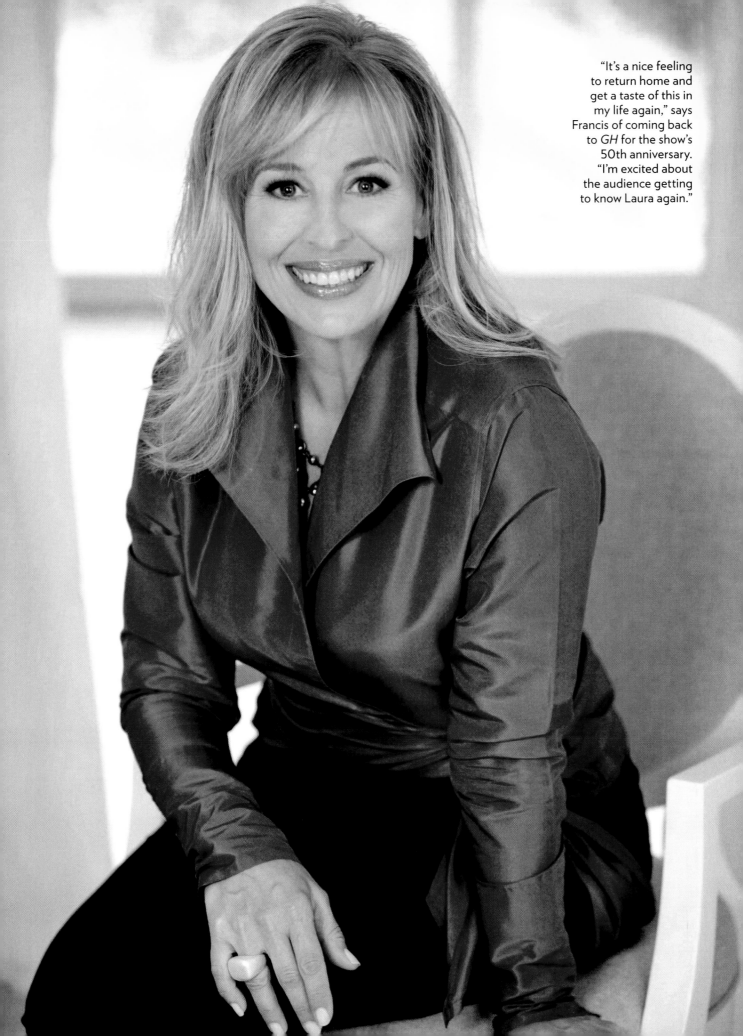

"It's a nice feeling to return home and get a taste of this in my life again," says Francis of coming back to *GH* for the show's 50th anniversary. "I'm excited about the audience getting to know Laura again."

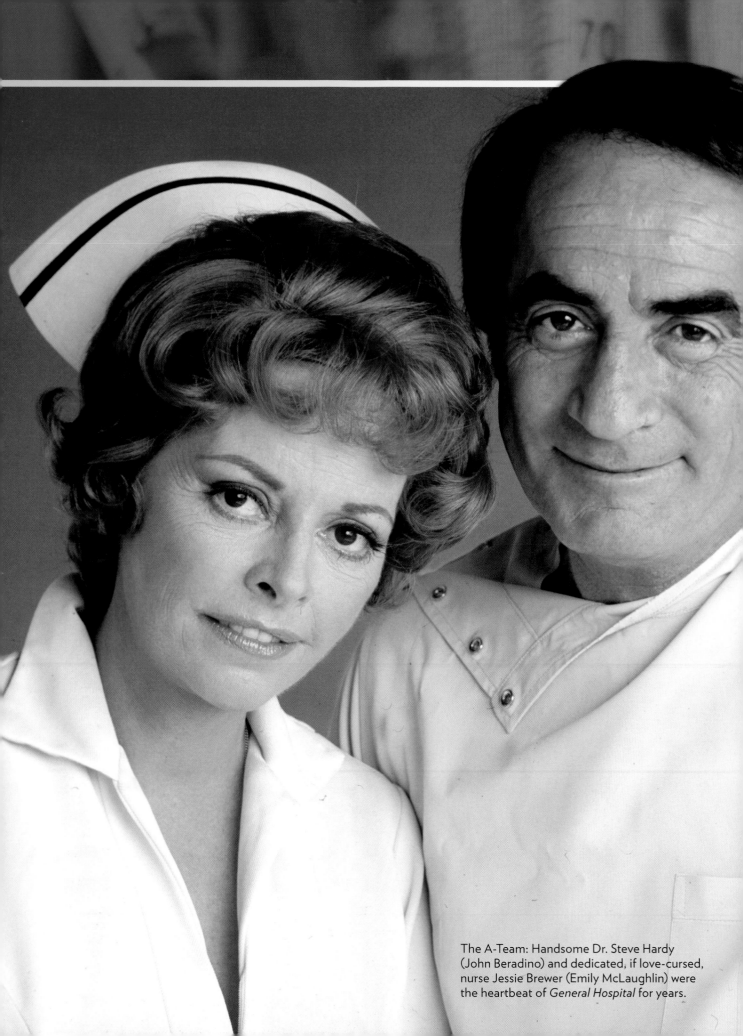

The A-Team: Handsome Dr. Steve Hardy (John Beradino) and dedicated, if love-cursed, nurse Jessie Brewer (Emily McLaughlin) were the heartbeat of *General Hospital* for years.

April 1, 1963: On the seventh floor of a large hospital in an unnamed American city, Dr. Steve Hardy, nurse Jessie Brewer and Dr. Phil Brewer were about to launch a television adventure that, 50 years later, keeps millions tuning in

THE (1960s)

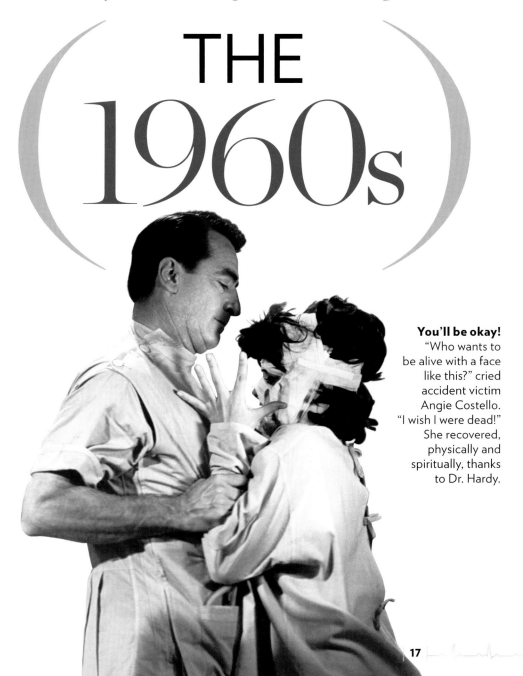

You'll be okay! "Who wants to be alive with a face like this?" cried accident victim Angie Costello. "I wish I were dead!" She recovered, physically and spiritually, thanks to Dr. Hardy.

edical shows were having a moment. *Dr. Kildare* and *Ben Casey* were primetime hits. ABC's original concept for what became *General Hospital* wasn't a serial; instead, each day, a policemen, a doctor and a nurse would encounter a problem and solve it during the episode. The network only shifted gears and created a more traditional serial when it became clear that another network also had a medical-themed soap opera in the works. In fact, ABC's *General Hospital* and NBC's *The Doctors* premiered on the very same day.

From day one, *GH*, centered on the seventh floor of a hospital in an unnamed East Coast city (the locale wasn't designated "Port Charles" until the '70s) seesawed wildly, and entertainingly, between medical emergencies—Lymphoma! Malaria! Murder by "Alkaloid X34"!—and the fraught romantic lives of doctors, nurses and even love- and lust-struck patients. At the heart of it all were medico-with-a-heart-of-gold-and-a-chin-of-granite Dr. Steve Hardy (John Beradino, who would stay with the show until his death in 1996) and his best friend and devoted nurse, the unlucky-in-love Jessie Brewer (Emily McLaughlin). Fans longed for them to get together but had to settle for decades of vague sexual tension.

And, alas, bad romantic choices on the part of Jessie, who *never* should have taken up with handsome, philandering Dr. Phil Brewer, seven years her junior. He dumped her for teacher Cynthia Allison ("I'm sorry I'm not as young and pretty as Cynthia!" Jesse cried). Then, missing Jessie, Dr. Phil got drunk and forced himself on her. For an encore, he had a secret affair with Polly, the scheming teenager who had gotten Jessie convicted *for a murder she did not commit*! Despite all that, Jessie found it difficult to permanently drop-kick the hunk of human Kryptonite out of her life.

Dr. Hardy, by contrast, initially seemed focused on everyone's life but his own; his first serious *GH* romantic interest, Peggy Mercer, sadly came to realize he was married to his job, and ran off with a writer. Dr. Hardy eventually fell for globe-trotting nurse-stewardess Audrey March, who thought there might be another, more passionate Steve Hardy lingering beneath that cool professional surface—"a real, living, exciting human being," as she put it, "a *man*, not just a doctor!"

"Audrey, you make me feel like I'm missing out on something," the doctor replied. "I've never met anyone like you before!"

There were, of course, dramatic moments of *romance interruptus*, most notably when Audrey developed feelings for rich-but-malarial businessman Randy Washburn and told Dr. Hardy, "I don't consider myself good enough for you, Steve! The kind of woman you ought to marry is someone like Jessie!" Still, they eventually tied the knot, but this being a soap opera, things did not go smoothly: Dr. Hardy confronted evidence he was sterile ("I feel

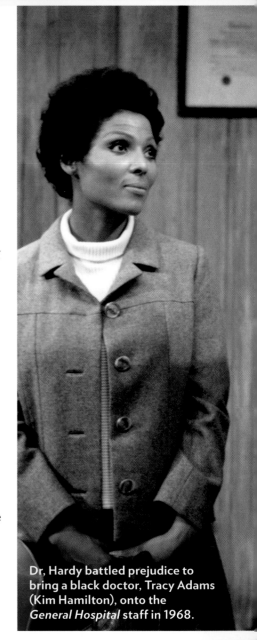

Dr, Hardy battled prejudice to bring a black doctor, Tracy Adams (Kim Hamilton), onto the *General Hospital* staff in 1968.

Nurse!
Actress Rachel Ames came aboard in 1964 as glamorous nurse-stewardess Audrey March, the woman who could finally get Dr. Steve Hardy to stop thinking about work and even walk down the aisle. Through trial and tribulation—including divorce from Steve, two more marriages, an invalidated remarriage to Steve, an assault or two and a hostage crisis—Ames remained with *GH* for nearly 40 years.

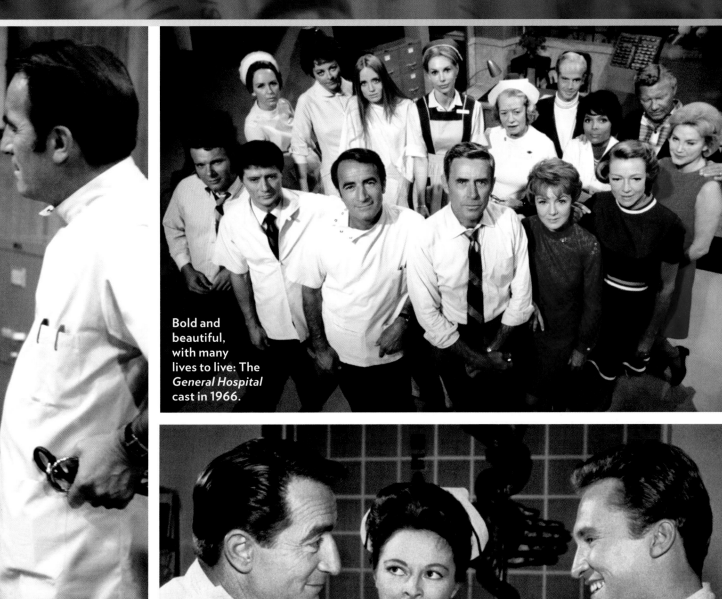

Bold and beautiful, with many lives to live: The *General Hospital* cast in 1966.

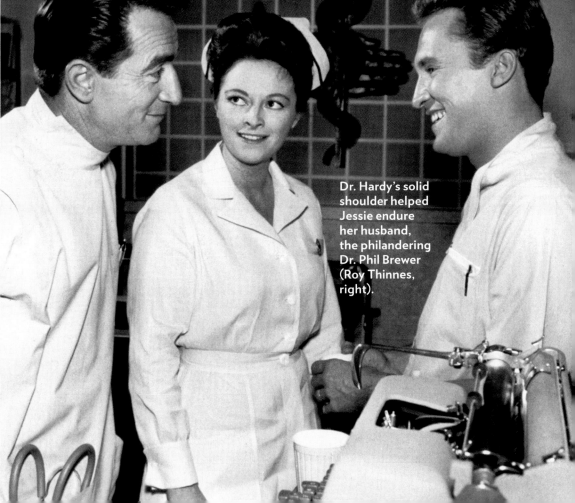

Dr. Hardy's solid shoulder helped Jessie endure her husband, the philandering Dr. Phil Brewer (Roy Thinnes, right).

like a failure as a man!") and, after tragedy damaged their marriage, Audrey filed for divorce and left to work with orphans in Vietnam.

But romantic passion was never Dr. Hardy's trump suit; more than anything, he was there to help the hopeless, as he did with teenage Angie Costello, who feared her beautiful young face—damaged in a car crash with her drunk boyfriend at the wheel, and still hidden in bandages—was forever scarred. "I don't want anybody to see my face!" she wailed. "Why don't you just leave the bandages on!"

"Angie, you can't hide behind those bandages forever!" Dr. Hardy replied. "Come back into the world again, live again!"

Angie later had to testify at her boyfriend's trial, but, thanks to the unrelenting efforts of Dr. Hardy and Jessie, she looked *great*.

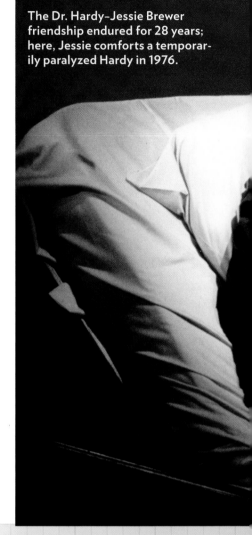

The Dr. Hardy–Jessie Brewer friendship endured for 28 years; here, Jessie comforts a temporarily paralyzed Hardy in 1976.

Vivacious nurse Sharon McGillis (Sharon Debord) and Dr. Henry Pinkham (Peter Killian) were just two of the lovebirds who flocked to the seventh floor nursing station.

The heartbeat of *GH*, one crisis at a time

1963

Dr. Steve Hardy treats his first patient, teenager Angie Costello, who contemplates suicide after her drunken boyfriend crashes his car, disfiguring her

1964

Dr. Phil Brewer, the younger, philandering husband of Nurse Jessie, returns to his wife after ending an affair, but when Jessie miscarries his baby she files for divorce

Peggy Mercer breaks off her engagement to Steve Hardy, realizing he's more devoted to his work than to her, but Hardy soon falls for formerly swinging stewardess Audrey March and proposes

General Hospital spawns a sister soap, *The Young Marrieds*, which runs for a year and a half

1965

Audrey and Steve finally marry, but when the baby she's carrying doesn't survive a car accident, she divorces him and leaves the country

Two years after Angie gave up her baby for adoption, she and her boyfriend reunite, kidnap the baby and flee to Chicago

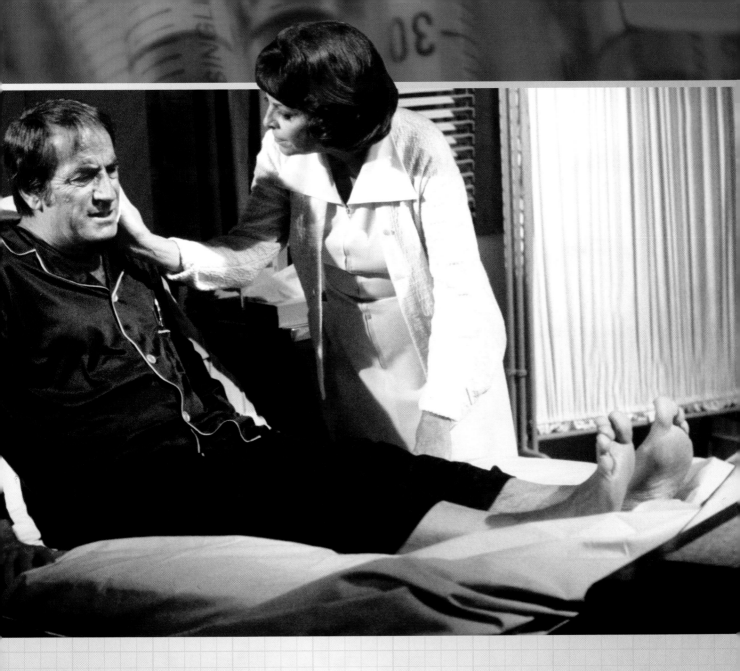

1966

General Hospital goes from black-and-white to color

Jessie becomes pregnant after her estranged husband Phil forces himself on her, but their baby Nancy dies of a heart ailment that Phil, a cardiologist, can't fix

1968

Steve Hardy hires kidney specialist Dr. Tracy Adams and *GH* gets its first black character

Jessie is tried and convicted for the murder of her new husband, Dr. John Prentice, but Phil fights to discover the truth that ultimately exonerates her. When she's sprung, they remarry

As always, Phil Brewer returns to his philandering ways, this time with Polly Prentice, the young woman who wrongly accused his now-wife, Jessie, of murder

1969

Audrey marries Tom Baldwin to convince herself she's over Steve, but after Tom rapes her, she leaves town again

Jessie learns of a plane crash in South America that killed everyone on board, including one P. Brewer. Assuming Phil is dead, she soon marries Dr. Peter Taylor

Dr. Steve Hardy makes a guest appearance on ABC's new soap, *One Life to Live,* during its first season to help promote the show

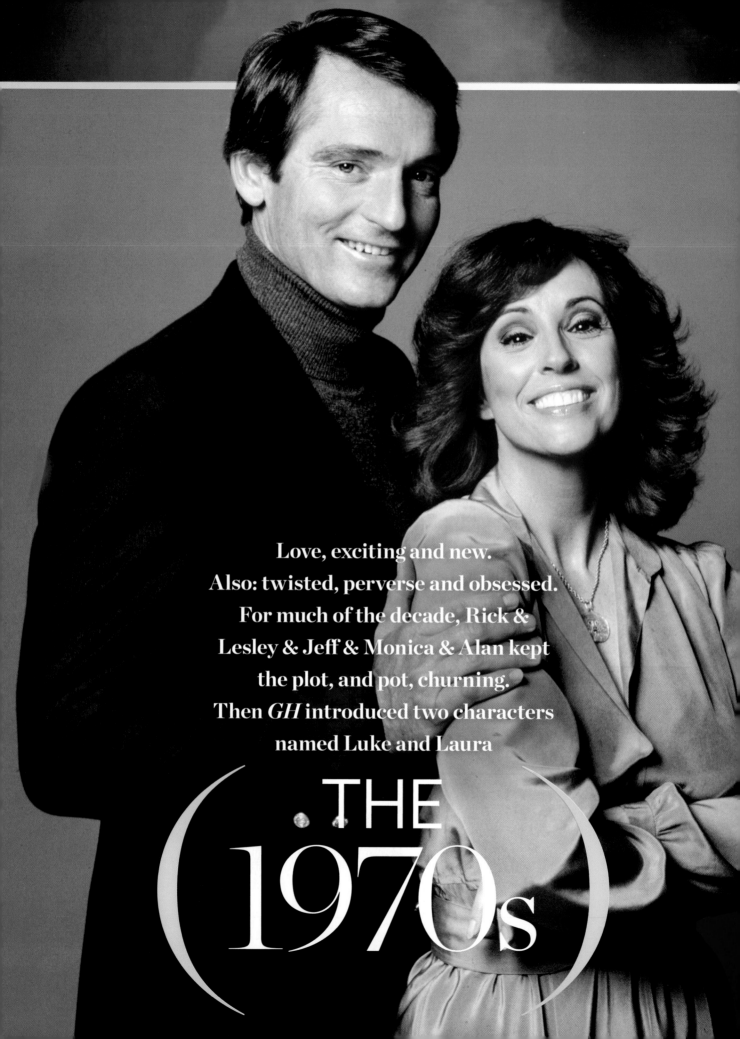

Love, exciting and new.
Also: twisted, perverse and obsessed.
For much of the decade, Rick &
Lesley & Jeff & Monica & Alan kept
the plot, and pot, churning.
Then *GH* introduced two characters
named Luke and Laura

THE (1970s)

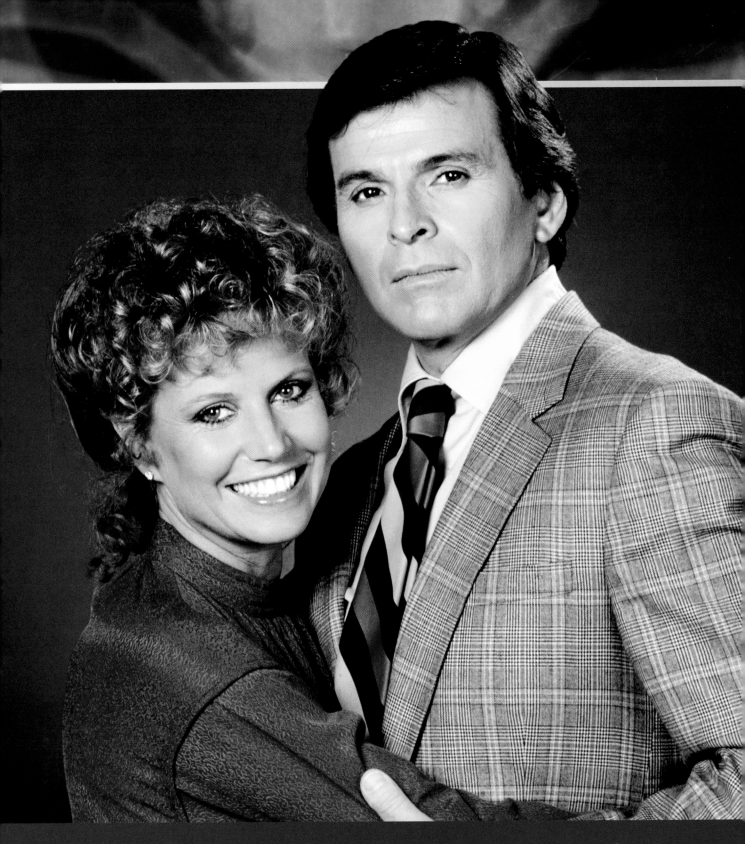

Monica, Monica, Monica: Is there *nothing* you won't do to get your man? You, Monica Webber Quartermaine (first played by Patsy Rahn and later by Leslie Charleson, above), were the black heart of *GH* in the mid- to late '70s. You torpedoed your (outwardly) perfect marriage to Dr. Jeff Webber by having an affair with his brother Rick (Chris Robinson, left)! Then you tried to deep-six Rick's upcoming marriage by blackmailing his fiancée Lesley (Denise Alexander, left)—which so upset her that she fell down the stairs and lost her baby! And when Rick and Lesley finally *did* get married, you slept with him *again*—*after* marrying handsome doctor Alan Quartermaine (Stuart Damon, above)! And we're not even going to talk about how you SLEPT WITH YOUR FOSTER MOTHER'S HUSBAND! Monica, Monica, Monica!

Most of the '70s reinforced the Great Soap Opera Verities: 1) Anyone who dies off-camera *will* come back to life (Phil Brewer in a plane crash in South America, Rick Webber in a plane crash in Africa); 2) any sex you regret will, of course, lead to pregnancy (Lesley Faulkner, Jeff Webber with Heather); and 3) good news is, frequently, a bad omen (Dr. Steve Hardy, after discovering Audrey still loves him, falls down a flight of stairs and is paralyzed). And one more thing: that baby your wife is about to have? Er, it's *just maybe* not yours.

In the world of men, Nurse Jessie continued her epic run of bad luck. Her romance with charming journalist Teddy Holmes came a cropper when he put her in debt and ran off with her 18-year-old niece. Then someone killed her ex, Phil Brewer, with a blunt instrument—and Jessie was jailed *for a murder she did not commit!* In the middle of the decade, Monica arrived to start messing, memorably, with anyone who came between her and Rick.

After a while, though, repetition began to pall; by 1978, ratings had dropped so far that *GH* was in danger of cancellation. ABC hired brash producer Gloria Monty in to shake up the show; instead, she shook up the industry. Before long, *General Hospital* was No. 1 again—and enjoying the highest ratings in soap history.

Audrey is tried for murdering her son's babysitter; *GH* scores its best ratings to date

1971

Genie Francis takes over the role of Laura Webber

Lesley falls down the stairs and loses her baby; soon, she'll marry Rick, and Monica will divorce Jeff

1977

1970

1976

When the bandages are removed from a mystery patient, Jessie discovers he's Phil Brewer— her late husband!

Jeff and Monica's marriage begins to sunder when it's discovered her real love, his half brother Rick, long thought dead in a plane crash, is alive!

1975

Dr. Lesley Faulkner discovers her infant daughter didn't die 12 years ago but instead was switched at birth— and the character of Laura is introduced to the show

Laura accidentally kills her older lover, David Hamilton; her mother, Lesley (below right), goes to jail to protect her

Ratings collapse; ABC hires game-changing producer Gloria Monty

Real-life psychologist Irene Kassorla begins conducting group therapy sessions on the show

1978

Luke Spencer (top) appears for the first time when his conniving sister, Bobbie (above left), uses him to try to get Scotty (above, right) back from Laura

1979

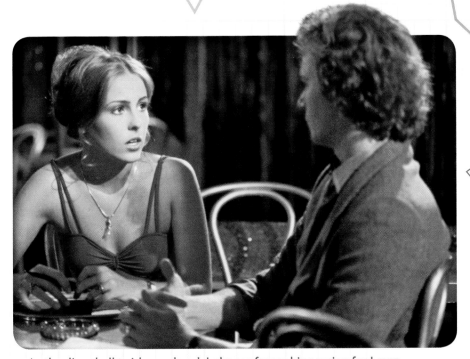

As the disco ball twirls overhead, Luke confesses his passion for Laura, then rapes her. When producers realize fans are fascinated by the pair, they alter the story line so that the pair fall in love. Later, Laura will tell Luke that she had feelings for him and it wasn't really rape

Evil Heather ends up in a mental institution after accidentally drinking LSD-laced tea she had planned to give to Diana

Audrey tells Jeff Webber the big secret: Dr. Steve Hardy is his father!

Delirious, Monica cries out that Rick, not Alan, is the father of her baby!

GH becomes the highest-rated soap on daytime

THE (Full Monty)

General Hospital was sagging in the ratings in 1978 when ABC hired Gloria Monty, 56, as executive producer. *Good move*—in fact, perhaps the best in the history of daytime drama.

Petite and driven, Monty, who had previously directed the soaps *The Secret Storm* and *Bright Promise*, came in swinging: She sacked older actors, spiffed up the sets, jacked up the pace and introduced grittier, and dicier, plots—Luke's rape of Laura being Exhibit A. (Longtime star John Beradino may not have been joking when he complained of being pushed aside by young "freaks, creeps, pimps and hookers.") She ditched the safe confines of General Hospital's seventh floor and went on location—with unheard of story lines about evil plotters and magical Makuthian swords.

The results would prove remarkable, but the process was wrenching. "Gloria would crack the whip," recalls Brian Patrick Clarke. "You never knew which Gloria you were going to get." Says Leslie Charleson: "I'm sure [the stories] are all true. There were a lot of actors that went screaming out of the business in tears." Former head writer Patricia Falken Smith, who quit along with six other scribes, felt more strongly: She's "a genius," said Falken Smith, "who runs a Gestapo operation."

But Monty saved the show, and changed TV. "She was a force of nature, a tiny woman who was an enormous talent," says Anthony Geary. "We're still walking around in her shoes here."

She was also a gold mine. Three years after her arrival, *GH* was earning $50 million a year—about double the profit of the far-more-expensive-to-produce nighttime soap *Dallas*. Monty left in 1987 but, when *GH*'s ratings fell, was brought back in 1990. She failed to recapture the old magic—even bringing Geary back as Luke's look-alike blue-color cousin, Bill Eckert, flopped—and left after two years. But the revolution she sparked changed soaps ever after.

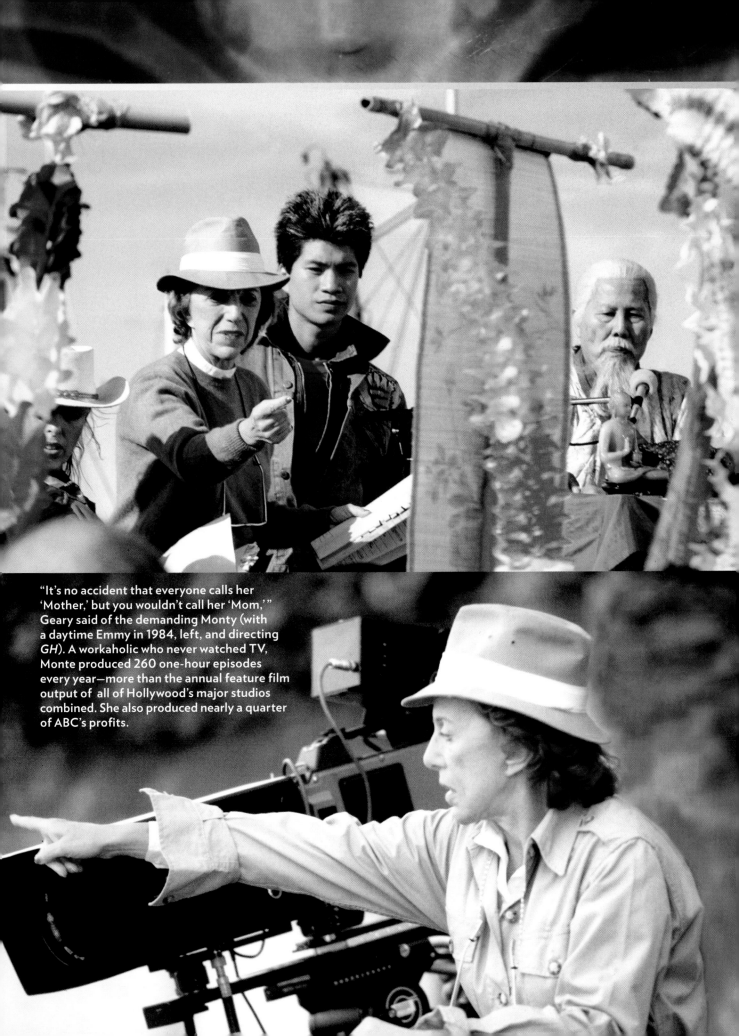

"It's no accident that everyone calls her 'Mother,' but you wouldn't call her 'Mom,'" Geary said of the demanding Monty (with a daytime Emmy in 1984, left, and directing *GH*). A workaholic who never watched TV, Monte produced 260 one-hour episodes every year—more than the annual feature film output of all of Hollywood's major studios combined. She also produced nearly a quarter of ABC's profits.

Super Couples

One generation of the lustful, conniving and lovelorn fades and another arrives; but *General Hospital* abides forever. So it was in the 1970s when the focus of story lines and bloodlines shifted from Dr. Steve Hardy to his out-of-wedlock son Jeff Webber and Jeff's half brother Dr. Rick Webber. Enter

gorgeous intern Monica Bard; much begetting, lying with and lying to ensued. She married Jeff after her fiancé Rick was killed in Africa—the continent where death is seldom, it seems, forever— only to cause major marital difficulties when he turned up undead. Thanks to Jeff's rebound marriage to beauty-with-mental-problems Heather Grant and Rick's hookup with pregnant widow Lesley Faulkner, things got even more complicated.

By decade's end, Lesley's daughter Laura had grown into a beautiful young killer—she accidentally shot her older lover

The straw that stirs the drink: The evil machinations of hooker-turned-nurse Bobbie Spencer (Jacklyn Zeman) launched the Luke and Laura phenom.

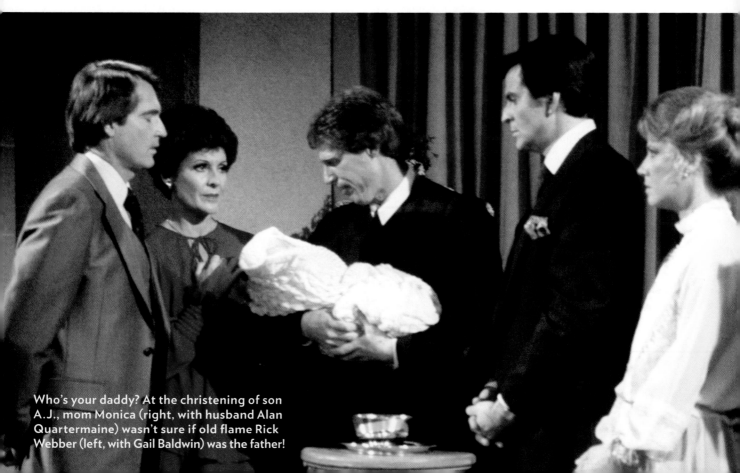

Who's your daddy? At the christening of son A.J., mom Monica (right, with husband Alan Quartermaine) wasn't sure if old flame Rick Webber (left, with Gail Baldwin) was the father!

after he scorned her. Laura wed handsome Scotty Baldwin, whose ex, (very) bad girl Bobbie Spencer, then enlisted her thuggy brother Luke (newcomer Anthony Geary) in a series of nasty plots intended to undo the two. When Luke found himself falling for wholesome, fresh-faced Laura and she thrilled to his edgy presence, the stage was set for *GH*'s most intoxicating coupling of all. But viewers were left with an unsettling cliffhanger when Luke and Laura's first passionate embrace went way, way over the line.

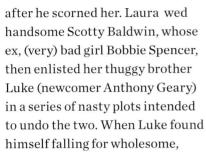

Heather and Dr. Jeff Webber

Laura and Scotty

Gail and Lee Baldwin

Sure Scotty Baldwin and Laura Webber (left) had their problems. But things really went downhill once Laura lost her heart to Luke, leaving the once-sweet Scotty a bitter bad guy. How bad was Heather (top, with hubby Jeff Webber), Scotty's future wicked soulmate? So bad she sold her own baby on the black market. Such antics would keep Port Charles psychiatrist and attorney husband-and-wife team Gail Adamson and Lee Baldwin (above) working overtime.

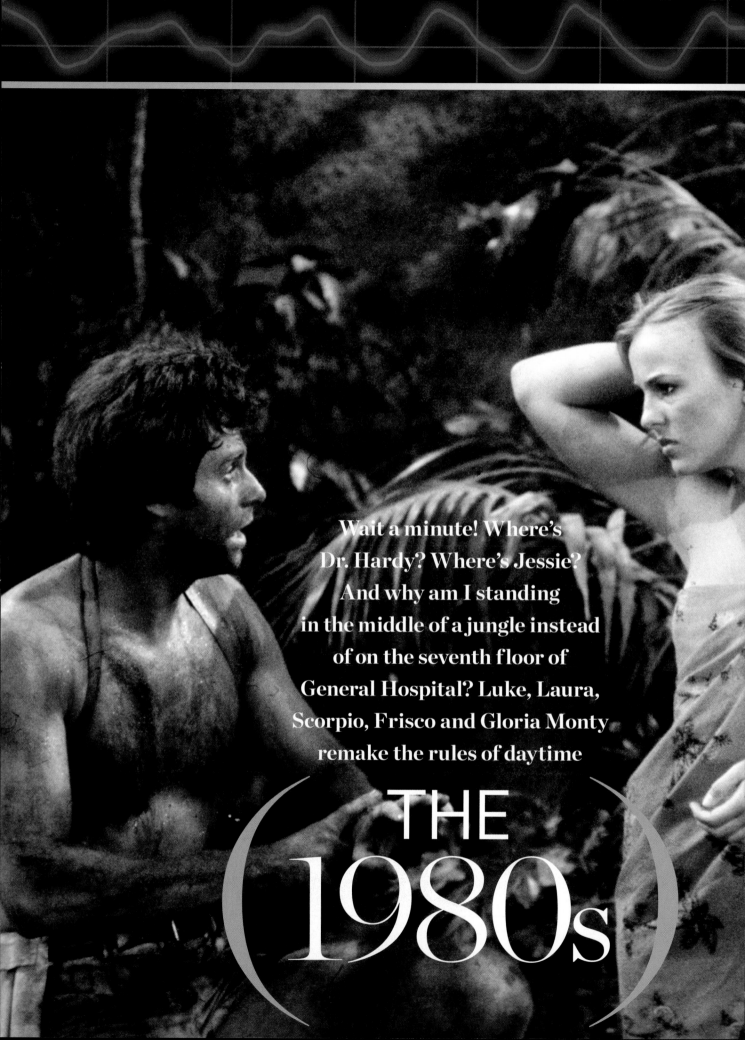

Wait a minute! Where's Dr. Hardy? Where's Jessie? And why am I standing in the middle of a jungle instead of on the seventh floor of General Hospital? Luke, Laura, Scorpio, Frisco and Gloria Monty remake the rules of daytime

THE
(1980s)

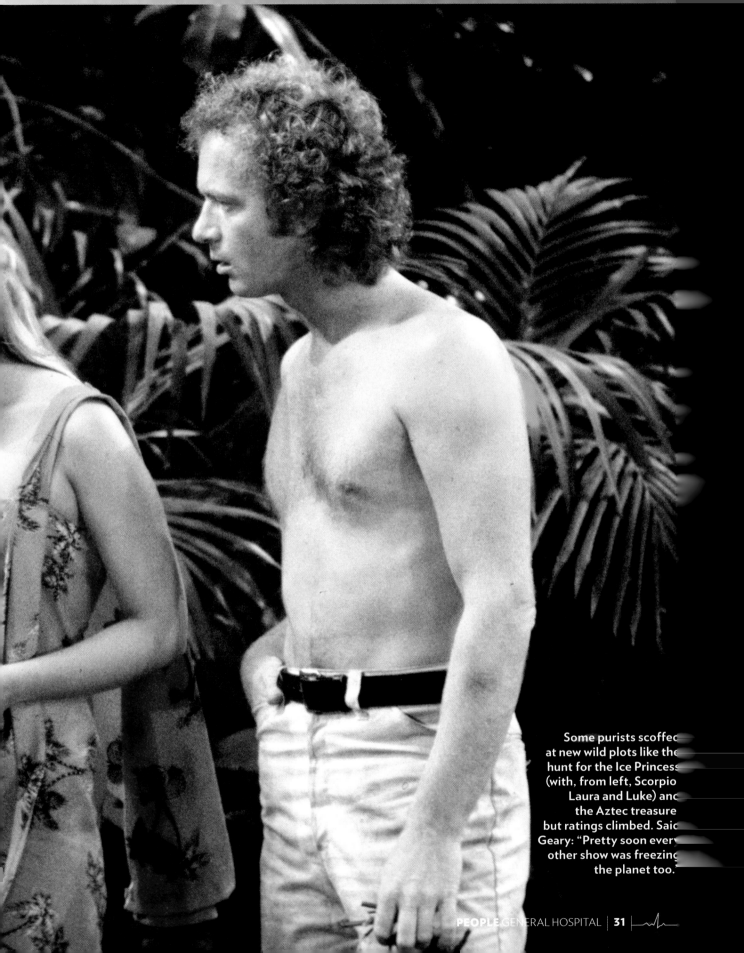

Some purists scoffed at new wild plots like the hunt for the Ice Princess (with, from left, Scorpio, Laura and Luke) and the Aztec treasure, but ratings climbed. Said Geary: "Pretty soon every other show was freezing the planet too."

Call it alchemy, call it harmonic convergence. But don't call it predictable: Whatever happened to *General Hospital* in the early '80s—some once-in-a-lifetime combination of Gloria Monty's fevered vision, Luke and Laura's charisma, and a sudden, unquenchable American appetite for romantic fantasy—produced a daytime phenomenon unseen before or since.

Luke and Laura's summer on the run—pursued by not one but two hitmen, one in drag—drew legions of fans and eventually led to their November 16-17, 1981 wedding, days that will live forever in soap history. Still, although it was the biggest *General Hospital* event of the '80s, it was far from the decade's only hallmark. Breaking free of the constraints of medical drama, Monty introduced wild plots, chief among them Mikkos Cassadine's scheme to freeze Port Charles, and everyone in it, like a giant Popsicle. Luke saved the city, and the world, by typing a secret code into a computer at the last possible second.

Monty also continued creating supercouples and compelling characters, including, notably, dashing-secret-agent-posing-as-a-playboy-financier Robert Scorpio (Tristan Rogers), who, over the course of the decade, pulled a gun on Luke; got knocked unconscious by Luke; became Luke's best friend; and—after Luke disappeared in an avalanche—married Luke's pregnant girlfriend, Holly, so she could stay in the country.

Tracy refuses to give her dying dad, Edward Quartermaine, his heart medication unless he changes his will. He reveals he's not really having a heart attack—just kidding, dear!—and casts her out

Discovering he's been cuckolded, Alan tries to murder Monica and Rick

Luke and Laura go on the run

1980

1981

Luke and Laura and their friend Robert Scorpio save the world by tracking down the Ice Princess statue

Heather escapes from the sanitarium determined to kill Diana Taylor and reclaim her son

In the soap event of the 20th century, 30 million fans watch Luke and Laura say "I do"

Luke, the new mayor of Port Charles, is reunited with Laura, who says she's been held captive by the Cassadines but doesn't mention that she has had a child with Stavros

After a quarrel with Holly, Luke goes camping in the mountains and is buried in an avalanche

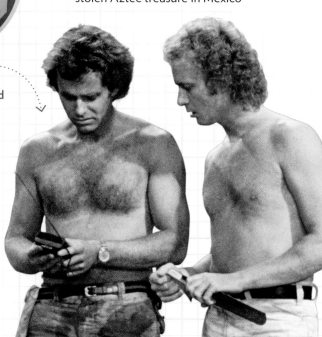

1983

1984

Quartermaine blackmailer Beatrice LeSeur collapses and dies at Port Charles's annual charity ball after several Quartermaines spiked her drink with knockout drugs

Luke, Scorpio, Frisco and Felicia search for stolen Aztec treasure in Mexico

Finola Hughes joins *GH* as former WSB agent Anna Devane, Robert Scorpio's ex-wife

Bobbie is charged with murdering her husband

1985

1986

1987

A nefarious KGB-like group, the DVX, seizes General Hospital and poisons Bobbie with a virus that leaves her paralyzed

Trying to save the world from nuclear fiasco, Anna, on horseback, catches up to a speeding train. Later, when she needs to be rescued, Duke swoops in by helicopter

1988

Anna, kidnapped by Grant Putnam and guarded by a Doberman named Satan, escapes, gets lost and is rescued by Scorpio, who swoops in by snowmobile

Kevin tries to kill his wife, Terry, but instead goes over the cliff himself

1989

Frisco, given up for dead, returns to Port Charles and has a tender reunion with Felicia in the town's catacombs

A portrait of Edward Quartermaine—who is presumed dead— begins talking to Lila

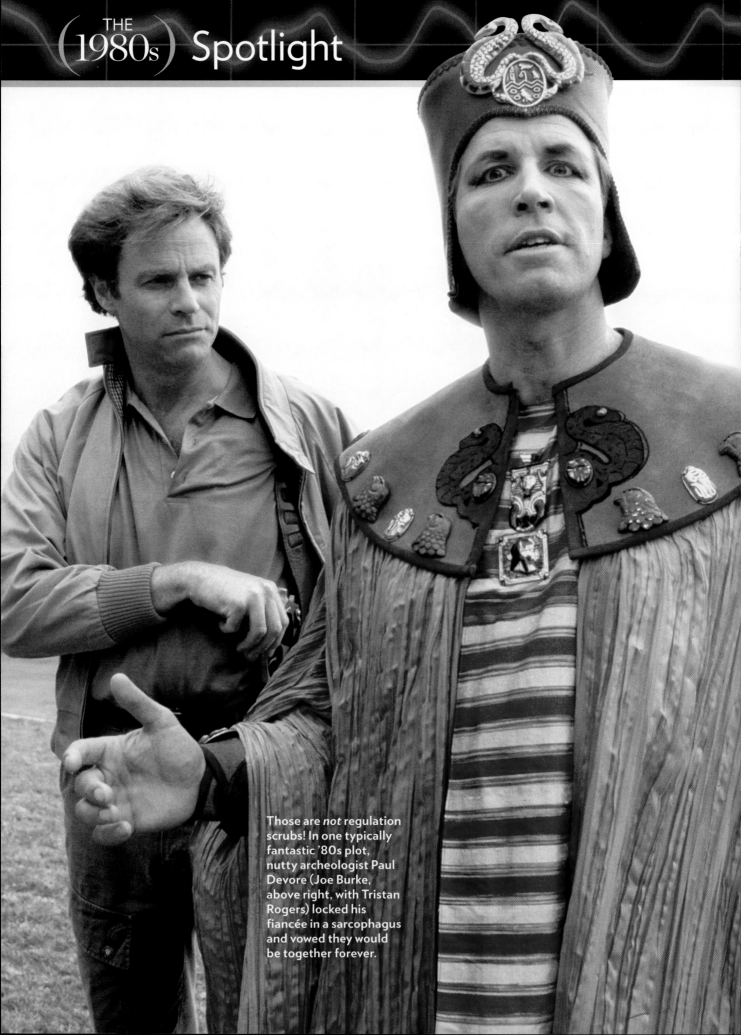

Those are *not* regulation scrubs! In one typically fantastic '80s plot, nutty archeologist Paul Devore (Joe Burke, above right, with Tristan Rogers) locked his fiancée in a sarcophagus and vowed they would be together forever.

The Outer Limits

The '80s marked a turning point for *General Hospital*—and, eventually, all soaps. Under Gloria Monty, plots shifted from love, lust and medical emergencies to wild sci-fi fantasies involving the Ice Princess (a blocky statuette containing the secret formula for Earth-freezing Carbonic Snow, enabling its possessor Evil Mastermind Mikkos Cassadine to boast, "The entire world will live by my rule! I will be in supreme command!"); the Sword of Malkuth (needed by the mysterious David Grey to help Evil Mastermind Magus overthrow a faraway kingdom); the Prometheus Disc (a top-secret energy source sought by a notorious international espionage organization, the DVX); and an Aztec treasure (Frisco's ring was a key to a secret vault; Luke, in pursuit of the loot, was framed *for a murder he did not commit!*). By comparison, another '80s plotline—the Secret of L'Orleans, involving a long-ago murder and a nun with amnesia—seemed positively quaint.

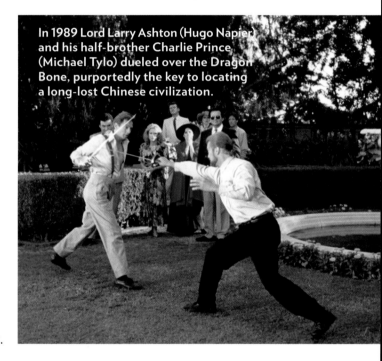

In 1989 Lord Larry Ashton (Hugo Napier) and his half-brother Charlie Prince (Michael Tylo) dueled over the Dragon Bone, purportedly the key to locating a long-lost Chinese civilization.

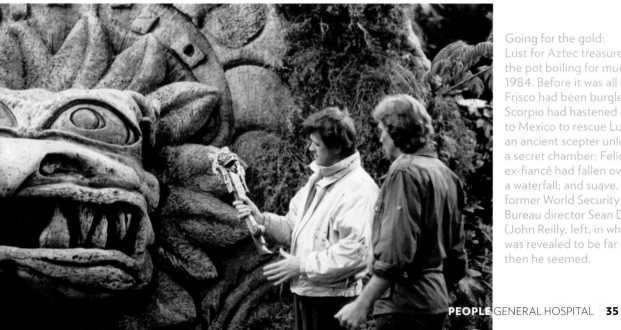

Going for the gold: Lust for Aztec treasure kept the pot boiling for much of 1984. Before it was all over, Frisco had been burgled; Scorpio had hastened to Mexico to rescue Luke; an ancient scepter unlocked a secret chamber; Felicia's ex-fiancé had fallen over a waterfall; and suave, smooth former World Security Bureau director Sean Donely (John Reilly, left, in white) was revealed to be far more then he seemed.

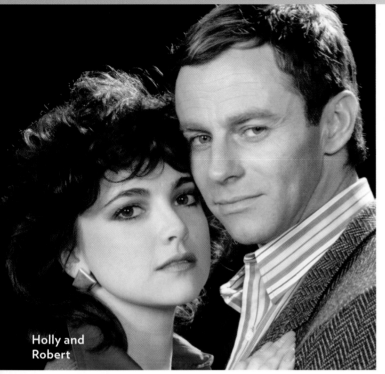

Holly and Robert

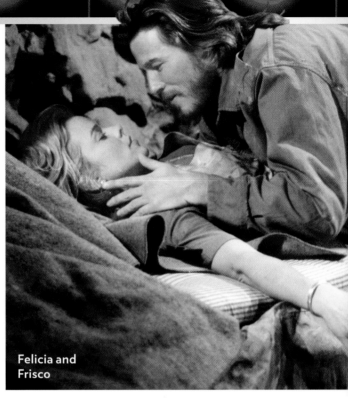

Felicia and Frisco

Super Couples

Sure, Luke and Laura were the decade's supercouple icons, but they weren't *GH*'s only red-hot romance. At least three other delicious duos kept viewers tuning in:

Aztec princess and amnesia victim Felicia Cummings (Kristina Wagner) and her dream lover, rock singer Frisco Jones (Jack Wagner), met cute, Shakespeare-style, when he caught her, disguised as a boy, trying to steal a ring from his bedroom. His death caused her much heartache; his sudden reappearance, a year later, merely caused her to faint.

The passion of Robert (Tristan Rogers) and Holly Scorpio (Emma Samms) survived all adversity, including the reappearance of her ex-love, Luke Spencer, whom she had mourned after his apparent death in an avalanche and the sudden appearance of Robert's ex-wife, Anna Devane (Finola Hughes), with a secret daughter in tow. Holly and Robert's love ended only when she died—completely and, it seems, irrevocably—in a plane crash. Robert, devastated, eventually found himself again drawn to . . . Anna Devane!

Too late! Devane, a onetime villain–turned–Port Charles's police chief, was now betrothed to the hottest guy in town, the dangerous but dashing Duke Lavery, a mobbed-up Scotsman with a seductive brogue. They kept their illicit love under the covers as best they could, but once the gangster and his police moll made a steaming hot spectacle of themselves on the dance floor at Duke's nightclub (right), all Port Charles learned what viewers had known all along—Great Scott, these two were hot for each other!

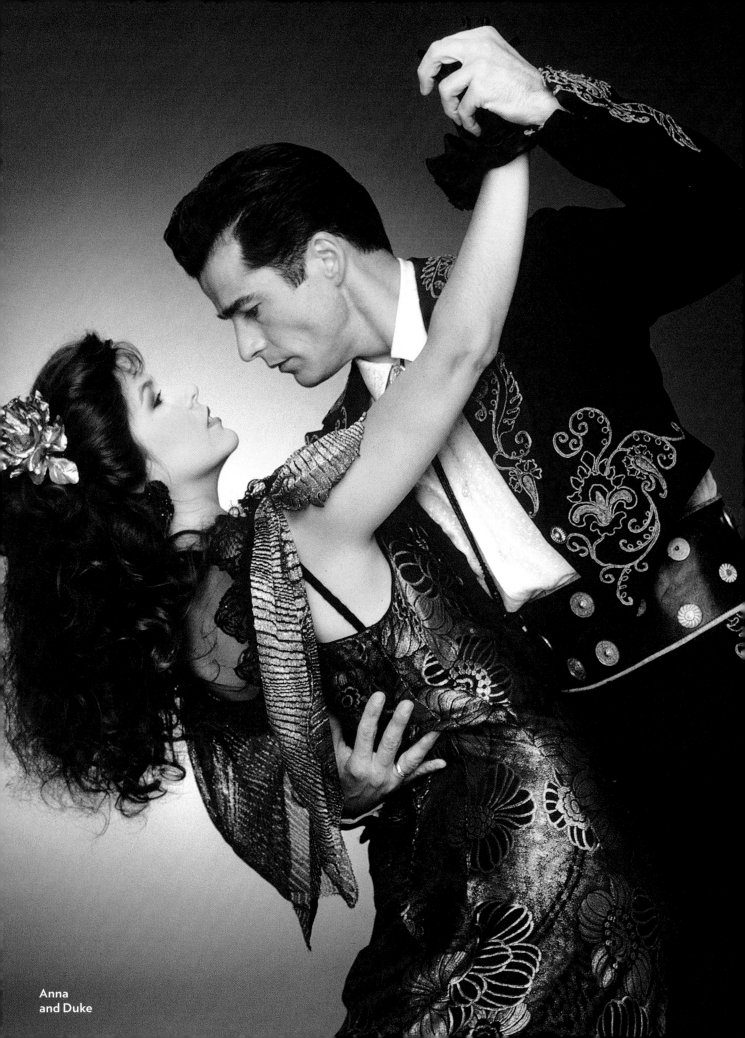

Anna
and Duke

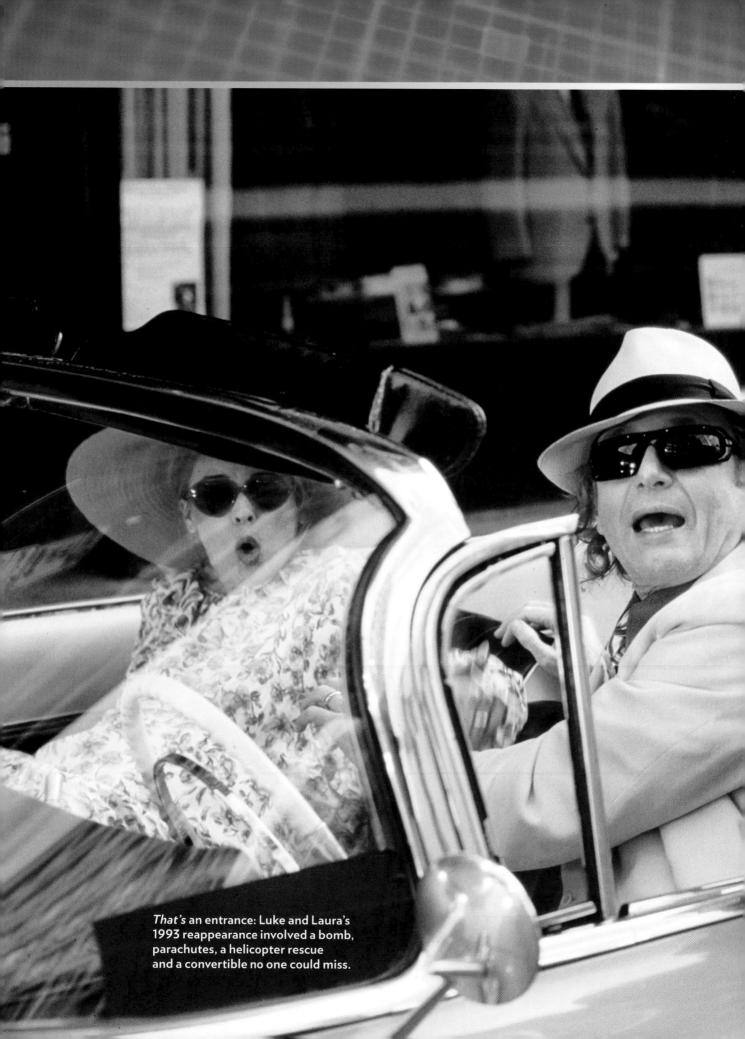

That's an entrance: Luke and Laura's 1993 reappearance involved a bomb, parachutes, a helicopter rescue and a convertible no one could miss.

Sci-fi fades, social issues
step to the fore,
and—who else?—Luke and Laura
come barreling back into
Port Charles in big pink Cadillac

THE
(1990s)

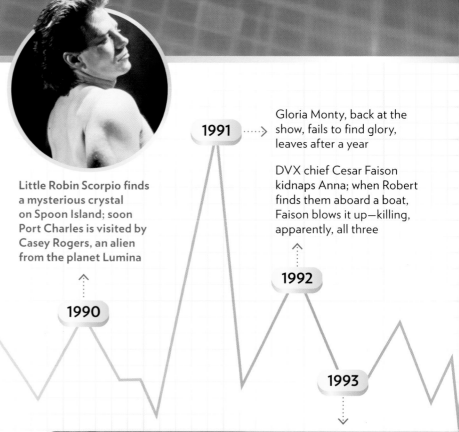

With the very notable exception of Casey the Alien—come to Earth, and Port Charles, to retrieve crystals from his home planet, Lumina—the '90s marked a turn away from fantasy and toward social issues. The usual romantic and criminal mayhem—the bomb in the hockey puck; the bomb in the wedding bouquet; the evil Faison using mind-control to get Anna to spy on Scorpio—continued, but *GH* also explored, through the lives of its characters, alcoholism, drug addiction, child molestation and, in very memorable story lines, breast cancer and AIDS.

Anthony Geary came back to the show, but initially played his look-alike blue-collar cousin Bill Eckert. When that failed to capture audiences, writer's brought back Luke and killed off Bill—who died in Luke's arms. "Who'd have thought," said Bill, staring into Luke's eyes, "that the last face I saw would be my own?" And . . . cut!

But the decade's biggest splash would be the 1993 return of Luke and Laura. On the run from murderous mobster Frank Smith, they had been happily, anonymously running a diner in Canada. But a bomb in their truck let them know Smith was onto them, so they decided to return to Port Charles—by airplane, parachute and Cadillac—intent on destroying Smith once and for all. After that, things got really complicated. As Laura said to Luke, "With Tiffany following Sean following you following me following Frank Smith, it's beginning to look like a conga line!"

Little Robin Scorpio finds a mysterious crystal on Spoon Island; soon Port Charles is visited by Casey Rogers, an alien from the planet Lumina

1990

1991 ┄┄> Gloria Monty, back at the show, fails to find glory, leaves after a year

DVX chief Cesar Faison kidnaps Anna; when Robert finds them aboard a boat, Faison blows it up—killing, apparently, all three

1992

1993

Scotty's wife, Dominique, dies of a brain tumor; later, a surrogate (Lucy, right) gives birth to their daughter Serena

Found in Canada by nemesis Frank Smith, Luke and Laura return to Port Charles by plane, parachute and Cadillac

Angie, Steve Hardy's first patient, returns for *GH*'s 30th-anniversary show

Although Edward Quartermaine opposes the relationship, his pooch Annabelle runs off with Luke and Laura's dog Foster and gives birth to puppy Raoul (below, center)

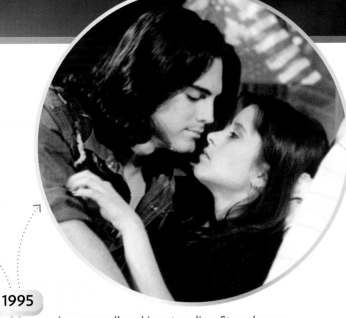

1995

In a groundbreaking story line, Stone learns he has HIV and later dies of AIDS

Brenda, in love with mobster Sonny Corinthos and refusing to believe he's dangerous, wears a wire

A.J., drunk, crashes his car, leaving Jason with severe brain damage

1994

Tony and Bobbie's daughter B.J. is left brain-dead after her school bus is hit by a drunk driver; her parents donate her heart to Frisco and Felicia's dying daughter Maxie, who survives

1997

General Hospital spawns a spin-off, *Port Charles*, featuring Lucy, Scotty, Kevin and, later, vampires

1998

Elizabeth Webber is raped; Lucky finds her and becomes her protector

Lucky is presumed dead in a fire; actually, he has been kidnapped by Helena Cassadine and Cesar Faison

1999

The first annual Nurses' Ball takes place in Port Charles to benefit AIDS research

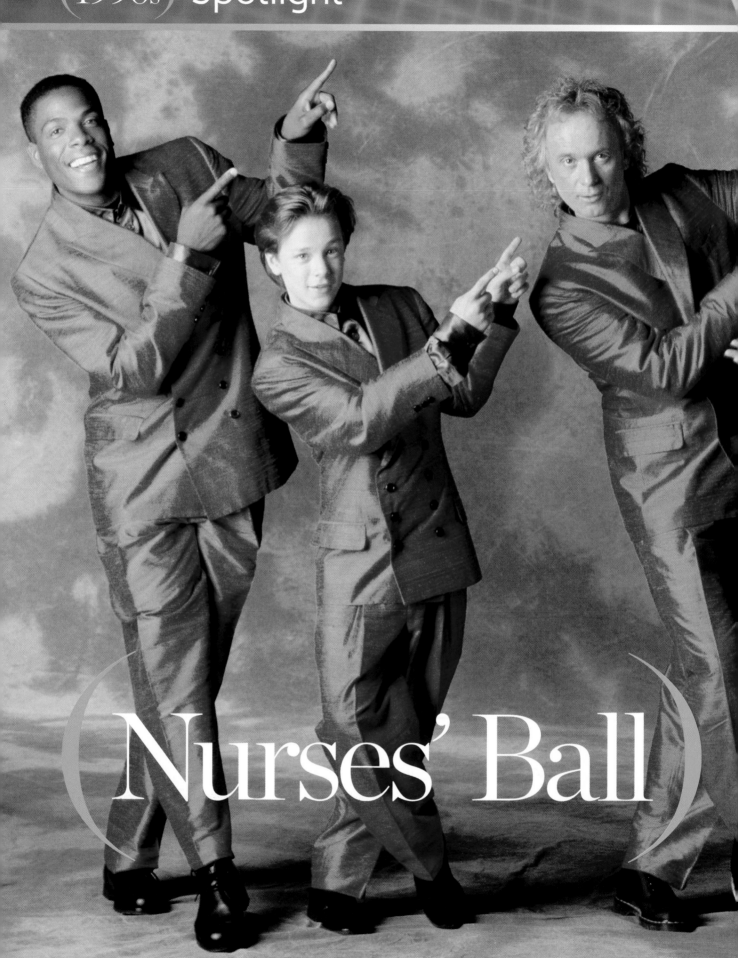

Nurses' Ball

E scapism seldom looked so good as when Port Charles's nice and nasty crew got together to put on their annual show-within-the-show. The Nurses' Ball, staged as an AIDS fund-raiser in 1994, became a '90s fixture and allowed *GH* stars (including, at left, Joseph C. Phillips, Jonathan Jackson, Anthony Geary and Rosalind Cash) to sing, dance and strut their characters'—and their own—hidden talents. *General Hospital* was one of the first soaps to shine the light of daytime on a health disaster that even many prime-time shows failed to address. Still, the message never overwhelmed the entertainment, which often ended with a wardrobe malfunction that left daffy dish Lucy Coe strutting her stuff in her skivvies.

An AIDS Moment

It was the least sudsy of story lines, yet it proved an all-time weeper. After playing Shakespeare's tragic teen lovers at the Nurses' Ball, Stone Cates (Michael Sutton) and Robin Scorpio (Kimberly McCullough) suffered their own tragedy in 1994, when Stone was diagnosed with HIV and later died of AIDs. Sutton was nominated for a Daytime Emmy for his portrayal and McCullough won one for her role as the surviving girlfriend who struggled with the emotional and physical fallout of her own infection. Awards came from distant quarters: Both the American Red Cross and the Ryan White Foundation praised the show for raising public awareness and for tackling issues such as safe sex and the dangers of prenatal infection.

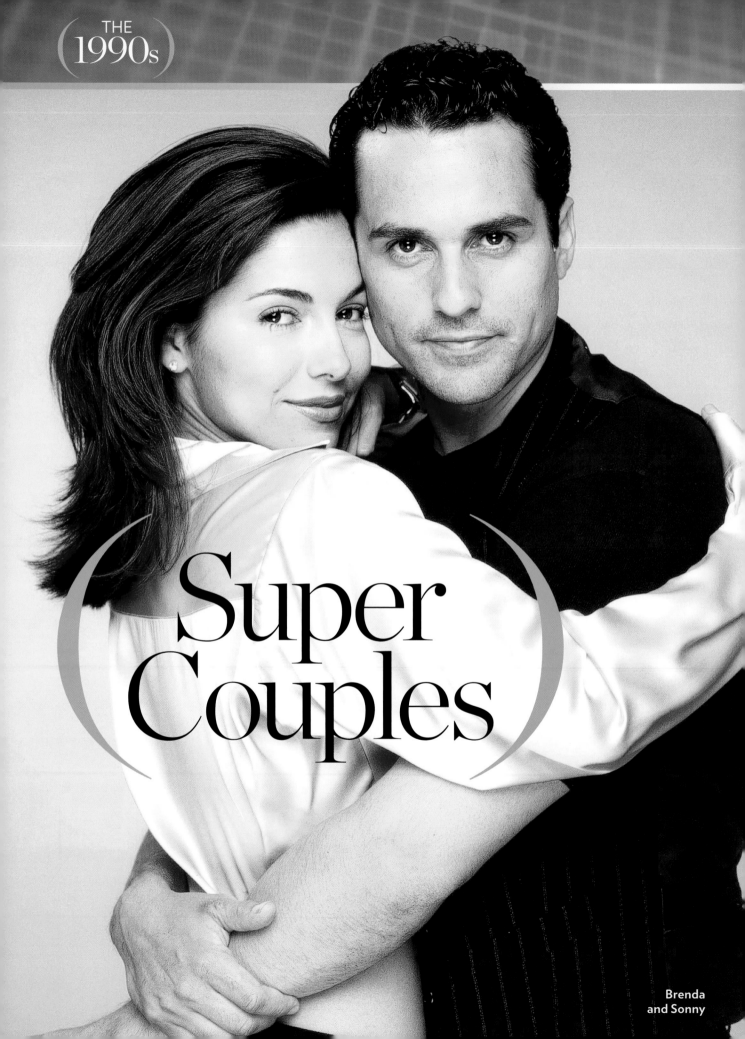

Super
(Couples)

Brenda
and Sonny

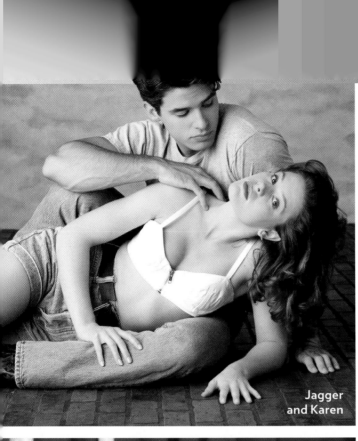

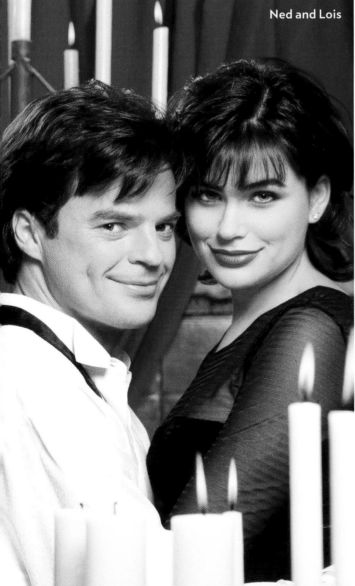

Jagger and Karen

Ned and Lois

There's no aphrodisiac like a brush with death. And when it comes on the heels of a speedboat chase in the Caribbean, that nearly sent Sonny and Brenda (far left) from here to eternity in 1994, *GH*'s First Couple re-created Burt Lancaster and Deborah Kerr's famous sand, sea and sex scene.

Nineties pop culture—rave parties and strip clubs—figured in the steamy story line that began with Jagger Cates and Karen Wexler's 1993 Valentines Day hookup. The couple (left) survived Karen's tripping and stripping and—yes—their love grew stronger.

Even though he led a double life as a rock singer named Eddie Maine, Ned Ashton's love for band manager Lois Cerullo (bottom left) was strong. And deep. A little hiccup (bigamy, on his part) did cause turbulence in their marriage—but that's nothing a surprise pregnancy can't solve! As for the two-timing Ned/Eddie's other wife, Katherine Bell: The news only got worse. Stefan Cassadine (below) accidentally shot her, paralyzing her, then asked her to marry him. Sadly, their engagement party was ruined when she fell to her (apparent) death from a parapet. Later, after becoming engaged to Stefan's uncle Nikolas Cassadine, she was pushed from the same parapet, with a more permanent result.

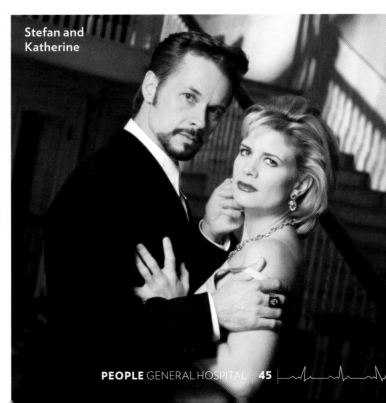

Stefan and Katherine

Married to the mob: For much of
the decade, love and romance ducked
for cover as bad guys and bullets
ruled Port Charles

THE
2000s

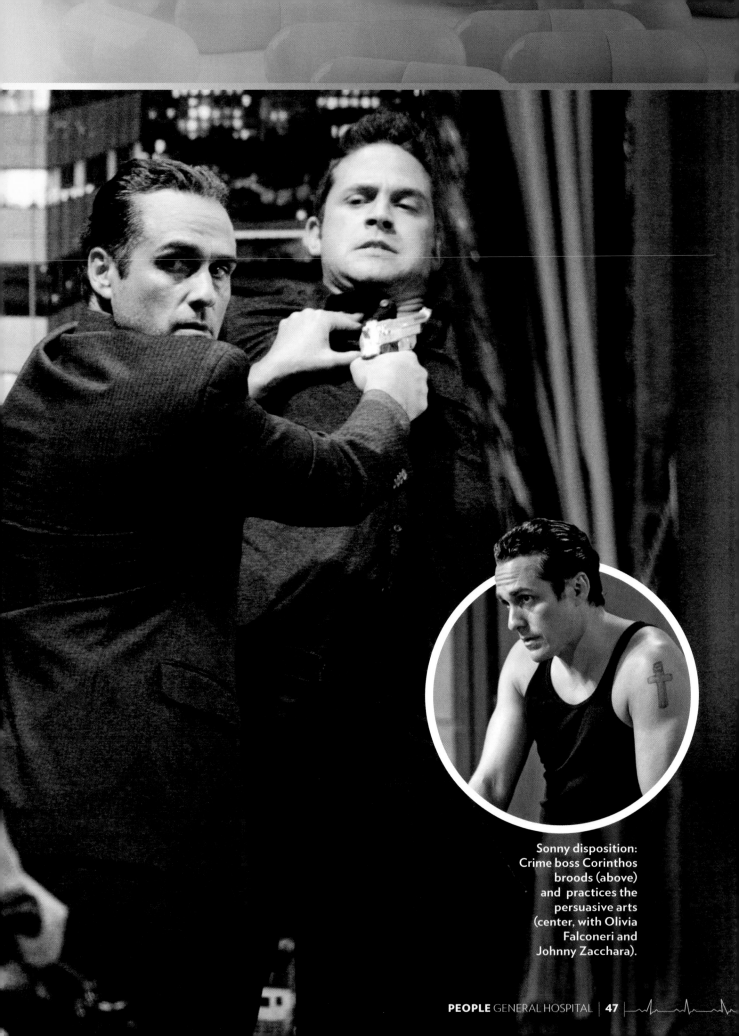

Sonny disposition: Crime boss Corinthos broods (above) and practices the persuasive arts (center, with Olivia Falconeri and Johnny Zacchara).

And: They're back! Laura reunited with Luke to search for their son Lucky, feared dead. Luckily, he'd only been kidnapped and brainwashed. Unluckily for Luke, once Lucky was safe, Laura left town again.

For the most part, however, *General Hospital* could have been retitled *It's Always Sonny in Port Charles.* The tormented mobster-with-soul dominated *GH*; rare was the day Sonny wasn't being shot at, stabbed, bombed or doing unto others in similar fashion. "Dark" would be an understatement: Sonny tortured A.J.; accidentally shot his own wife *while she was giving birth*; and plugged an unarmed cop— only to discover it was his own son!

Some fans thought the show was getting *too* dark. In 2012 a new team, headed by executive producer Frank Valentini and head writer Ron Carlivati, took over, intent on bringing a little more fun—and some favorite characters, including Scorpio and Anna Devane—back to *GH*. Ratings, bucking recent daytime trends, improved. "What Ron and I set out to do was, of course, put on the best show we could," Valentini says. "We strive to have multiple moments in every episode that are enjoyable and touching and that keep the stories moving forward. Getting positive feedback from fans has been so incredible."

Positive feedback from the cast hasn't hurt either. "I hadn't seen anybody quite like Gloria Monty until Frank came along," says Anthony Geary. "He's obsessed with the show. Frank and Ron have brought romance back to Port Charles."

Says Valentini: "We want to honor the past in a way that propels the story and the show forward so that *General Hospital* is around for another 50 years!"

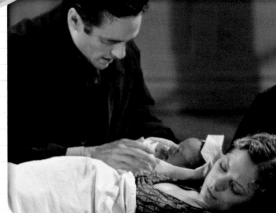

Alexis poses as a male butler named Dobson and goes to work at the Quartermaine mansion in an effort to get her kidnapped baby back

Firing at his rival Lorenzo Alcazar, Sonny accidentally shoots Carly as she's giving birth to his child

2003

2004

2005

Manny Ruiz causes a train wreck; Alexis almost dies but survives and gives birth to Molly

Trapped in a raging fire at the Port Charles Hotel, Alexis confesses to Carly that Sonny is Kristina's father; Edward Quartermaine suffers a heart attack; and Scott Baldwin is presumed dead

Matriarch Lila Quartermaine dies peacefully in her sleep after the death of Anna Lee, the actress who originated the role in 1978. All Port Charles attends the funeral

After Laura awakens from a catatonic state, she and Luke remarry on their 25th wedding anniversary; Tracy, to whom Luke is also apparently married at the time, gets drunk and has to be removed from the wedding. Later, the drug that revived Laura wears off, and she returns to catatonia

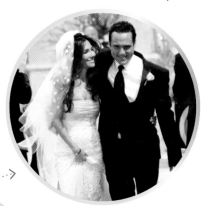

Lucky's 4-year-old son Jake is killed by a drunk driver—who turns out to be his own grandfather, Luke

Missing from Port Charles for seven years, Brenda returns and marries Sonny!

2006

Jerry Jacks takes Port Charles residents hostage at the Metro Court Hotel; Alan Quartermaine dies of a heart attack, Robin is shot and the lobby is destroyed by an explosion

2007

2011

2010

Havoc is wreaked at the Black & White Ball, when Anthony Zacchara terrorizes guests and Emily Quartermaine is strangled by the Text Message Killer

After killing his stepmother, Claudia, with an ax, Sonny's adopted son Michael is convicted of manslaughter

2012

Anna discovers that Duke is really Faison in a "Duke" mask; he subdues her with an injection

Franco (played by actor James Franco) terrorizes Jason and Sam; Jason kills him but later discovers Franco was his twin brother

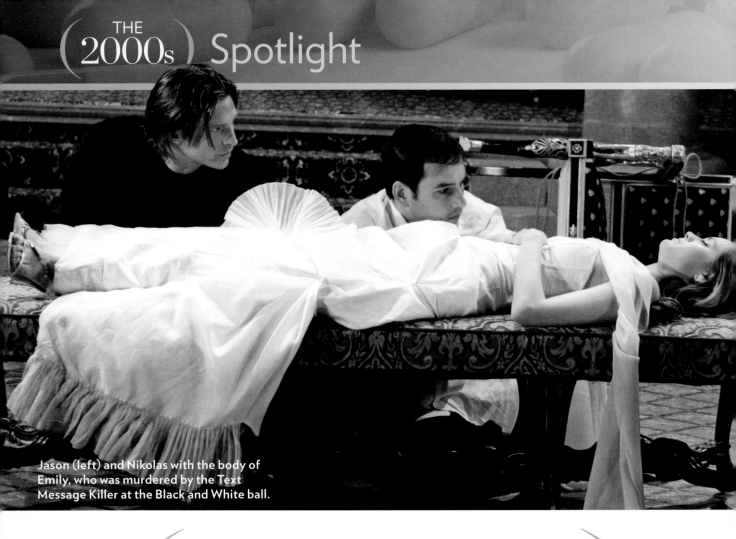

Jason (left) and Nikolas with the body of Emily, who was murdered by the Text Message Killer at the Black and White ball.

(Mayhem)

Bad things have always happened in Port Charles, but the 2000s, in particular, offered a cavalcade of calamity. For starters, tourists would be well advised to avoid the Metro Court Hotel, the scene of a 2007 hostage crisis—this after its predecessor was consumed by a raging fire in 2004. You might want to be careful about your mode of transport too: A 2005 train wreck left many of Port Charles's finest trapped in a tunnel. A night out wasn't safe, either: At 2007's fancy-dress Black and White ball, a blackout provided cover for not one but two homicidal maniacs, who between them caused Port Charles's population—historically subject to sudden fluctuation—to drop again.

Also, things in Port Charles—notably, cars and warehouses—tended to explode with impressive frequency. Jax's car blew up in 2007; soon after, Sonny's limo did the same. Kristina was saved from a car bomb in 2010, and another of Sonny's limos was smithereened in 2011. Which, by then, he should have been used to: His warehouses were blown up in 2004, and a ship in 2009. Someone blew up his pier in 2011 too. Which, of course, could only remind locals of that time Luis Alcazar blew up another waterfront warehouse in 2002.

Another tourist tip: When strolling the Port Charles waterfront, wear body armor. And, of course, sunscreen.

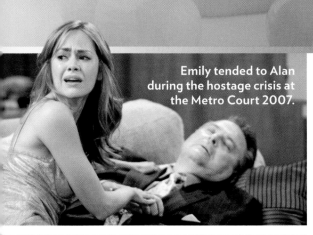

Emily tended to Alan during the hostage crisis at the Metro Court 2007.

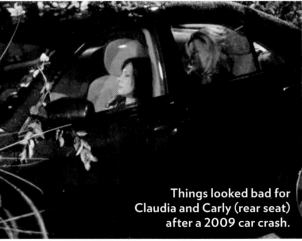

Things looked bad for Claudia and Carly (rear seat) after a 2009 car crash.

Sonny and Emily helped a pregnant Alexis from the wreckage after Manny Ruiz caused two trains to collide in 2004. Good news: Alexis's baby was okay!

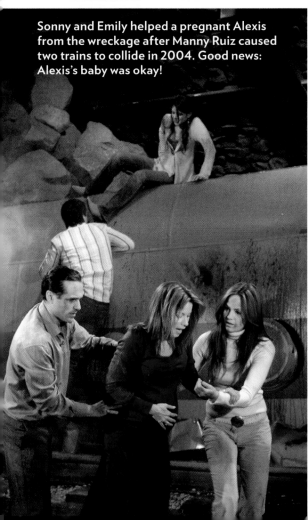

Wait! That's Not Duke!

Coming back from the dead, or the apparently dead, is so *done*; sometimes it seems that most major *GH* characters (Luke, Laura, Robin, Scorpio, Duke, Brenda, Jerry Jacks and A.J. Quartermaine among them) have Jet-Skied back across the river Styx at least once. So credit Cesar Faison, the evilest weasel alive, for coming up with a new twist: He not only came back, but came back as . . . Duke Lavery! Anna should have *known* there was something fishy about the "new" Duke—Scorpio *warned* her! But it wasn't until Anna discovered Faison was still alive, then saw him in the same room with a bound-and-gagged Duke, that she realized the man she had been thinking of loving again was just Faison in a rubber Duke mask! The plot allowed Ian Buchanan to play not only Duke, but Fasion playing Duke.

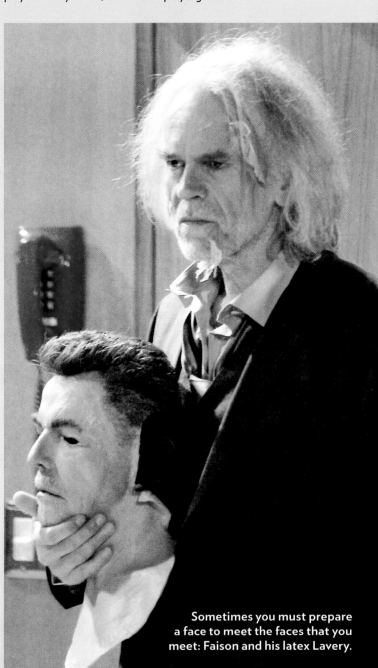

Sometimes you must prepare a face to meet the faces that you meet: Faison and his latex Lavery.

Super Couples

L ove on *GH* is never a walk in the park; it's more like running hurdles, or a gauntlet. *GH* lovers must *overcome.*

Dante and Lulu survived, among other things, the revelation that he was an undercover cop; his getting shot by Sonny, who turned out to be his dad; and Lulu's brief stint in a bordello (she was only a waitress!). Jason and Sam—aka "Jasam"— survived his risky surgery, her sleeping with her stepdad, and his getting his other Supercouple partner, Liz, pregnant. Maxie and Spinelli overcame (for a while at least) her past (man stealer, drug supplier, thief) and his regretted fling with Winifred the FBI agent.

But the Most Challenged Couple Award probably belongs to Patrick and Robin, who met, for the first time, as he was having sex with a nurse at the hospital. Since then they've survived his HIV scare; her getting shot during the Metro Court hostage crisis; his psycho ex, Dr. Lisa Niles; and Robin being kidnapped and left in the bottom of

a well. For a while, it also looked like her death in a lab explosion, which was followed by a funeral, might hurt their relationship. But later events suggested fans of Patrick and Robin should . . . stay tuned!

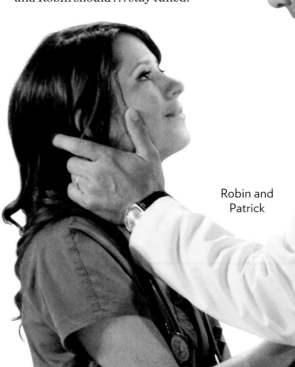

Robin and Patrick

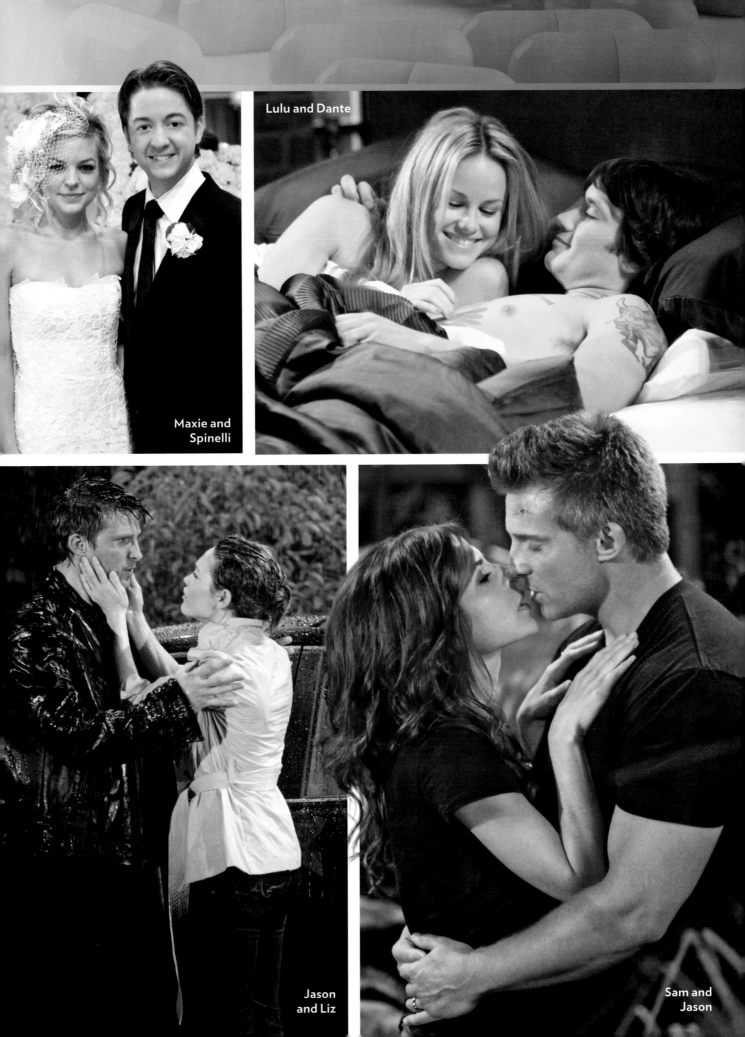

Maxie and
Spinelli

Lulu and Dante

Jason
and Liz

Sam and
Jason

They're hot! They're
headstrong! They're back
from the dead! Hippocrates
never imagined a *Hospital*
full of so many foxy physicians
and devilish angels

(The Cast)

MAURICE BENARD
Sonny Corinthos
Photographs by EMILY SHUR

A dark, brooding gangster who was abused as a child. And every time he opens his heart to a woman, it gets stomped like a grape. What's not to love—and root for?

For 20 years, Benard—whose original gig was supposed to last less than a year—has kept fans tuning in, and debating. Should he end up with Brenda? Well, *obviously*—except to viewers who, over the years, just *knew* he belonged with Carly. Or Claudia. Or Lily. "My fans are like my mother," says Benard. "No one is ever good enough for him except the one that they want!"

That said, two of his most popular story lines have involved other guys: Jason (actor Steve Burton), whom he took under his wing after the Quartermaine heir suffered a brain injury; and Stone (Michael Sutton), a street kid who died of AIDS. "Steve and I are incredibly close," says Benard. "We worked together almost 20 years. Fans tend to talk about the story with Stone the most."

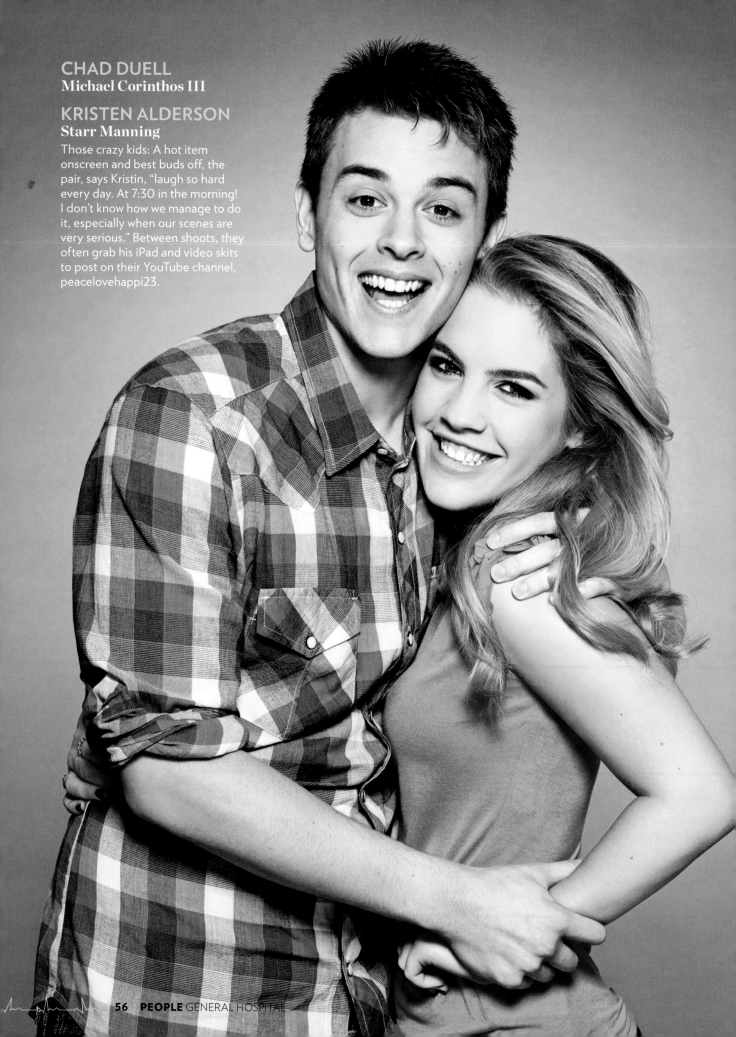

CHAD DUELL
Michael Corinthos III

KRISTEN ALDERSON
Starr Manning

Those crazy kids: A hot item onscreen and best buds off, the pair, says Kristin, "laugh so hard every day. At 7:30 in the morning! I don't know how we manage to do it, especially when our scenes are very serious." Between shoots, they often grab his iPad and video skits to post on their YouTube channel, peacelovehappi23.

LINDSEY MORGAN
Kristina Davis

Part of *GH*'s Generation Next, Morgan, who plays the daughter of mobster Sonny Corinthos and lawyer Alexis Davis, would love her character to combine her mom's drive and dad's line of business. "If it were up to me," says Morgan, "Kristina would take over the mob and get the city back together!"

KIRSTEN STORMS
Maxie Jones

Storms takes to her part, as the offspring of passion pair Frisco and Felicia, like a force of nature. After landing the role in 2005 (first played in 1990 by two child actresses) Storms proved her mettle by returning after a year-long medical leave and made Maxie, herself a transplant patient who has the heart of her late cousin, her own.

BRANDON BARASH
Johnny Zacchara

A chip off the old Port Charles godfather Anthony Zacchara, Johnny is a mob thug with murder in his heart. But no amount of evil soap doings will ever wash away the good karma Barash has amassed from his work on behalf of the Muscular Dystrophy Association. A USC drama graduate who serves as a spokesman for the MDA, Barash became involved with the organization after a childhood friend died as a result of the disease. "It's always been important for me to keep his memory alive and pick up fighting where he couldn't," he says. His friend, he added, "taught me a lot about life and believing in yourself, regardless of circumstances."

DOMINIC ZAMPROGNA
Dante Falconeri

His undercover-cop character was shot in the heart by mobster Sonny—then they discovered they were father and son! (Father's Day is probably still a bit awkward.) Although Zamprogna is a real-life father of two, his TV self was turned down for adoption because his family included mobsters, con men and Aunt Bobbie, a former hooker.

JULIE MARIE BERMAN
Lulu Spencer

Berman is at least the ninth actress— including, in the beginning, infant twins— to play soap opera's golden child, the daughter of Luke and Laura Spencer. The character has grown up fast, in fact, surreally so: Although she was originally born on Aug. 8, 1994, the date was later moved back to 1988 to facilitate more grown-up plot lines. Notes Berman: "It's fun to play a character in a mature relationship."

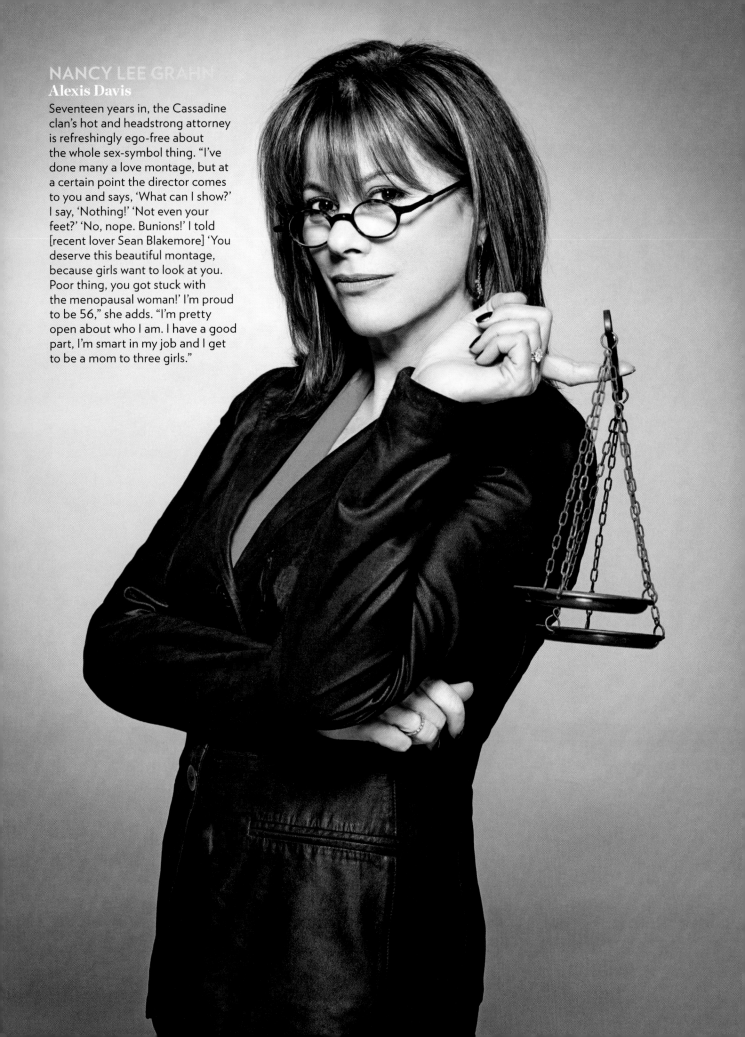

NANCY LEE GRAHN
Alexis Davis

Seventeen years in, the Cassadine clan's hot and headstrong attorney is refreshingly ego-free about the whole sex-symbol thing. "I've done many a love montage, but at a certain point the director comes to you and says, 'What can I show?' I say, 'Nothing!' 'Not even your feet?' 'No, nope. Bunions!' I told [recent lover Sean Blakemore] 'You deserve this beautiful montage, because girls want to look at you. Poor thing, you got stuck with the menopausal woman!' I'm proud to be 56," she adds. "I'm pretty open about who I am. I have a good part, I'm smart in my job and I get to be a mom to three girls."

BRADFORD ANDERSON
Damien Spinelli

Brought on as a teen computer geek, Anderson is thriving, six years later, as *GH*'s resident quirk, in part because of his odd friendship with manly man Jason Morgan. "So here was this alpha male being humanized by trying to help this guy along; there's comedy in that," says Anderson. "He was the best Dean Martin you could have found."

Leslie Charleson
DR. MONICA QUARTERMAINE

Hospital was on life-support and apparently bound for the morgue when Charleson, who had previously earned a footnote in TV history by giving Ron Howard's Richie his first kiss on *Happy Days*, helped resuscitate the show.

Within a year of her arrival, executive producer Gloria Monty engineered a turnaround that made it the most popular show on daytime, thanks in part to sparks that flew between Charleson's heart surgeon and her TV husband Dr. Alan Quartermaine, played by newcomer Stuart Damon. A lifelong off-camera friendship developed between the two. "I'd drive up in my '72 Cougar convertible," she recalls of giving Damon a ride to work each day when he joined the show in 1977. "Stuart would joke, 'Having a blonde pick me up in a convertible in Hollywood! It doesn't get better than this!'" But their warm feelings for each other didn't take the sting out of their characters' on-set altercations. "We'd do real slaps," Charleson says. "Stuart was always afraid I'd take his eye out. I could fake a slap in dress rehearsal, but when we went to tape it, all that went out the window."

The current show's longest-running cast member, Charleson says that before executive producer Frank Valentini and head writer Ron Carlivati took over in 2011, *GH* had again lost its way and she was ready to quit. "I had really come to grips with the fact that this was it," she says. "Then I get a call asking if I'm up for doing a lot of work. Okay! I couldn't be more pleased."

ROBIN MATTSON
Heather Webber

In the '80s, Heather escaped a sanitarium and returned to Port Charles to torment her enemies. Brought back to the show in 2012, she has—so far—kidnapped infants, hidden paternity tests and injected LSD into rivals. "I asked the producers if they were going to be true to Heather," she said of the invitation to return. "They told me what they had in mind, and I said, 'Sign me up!'"

ROGER HOWARTH
Todd Manning

Tabloid king, rapist and general no-goodnik Manning often schemes with Webber (left): "Their 'gray area' of morality makes for some fun scenes," he says. And that facial scar he brought with him when his character moved to *GH* from *One Life to Live* in 2012? "Lip liner. They just draw it on."

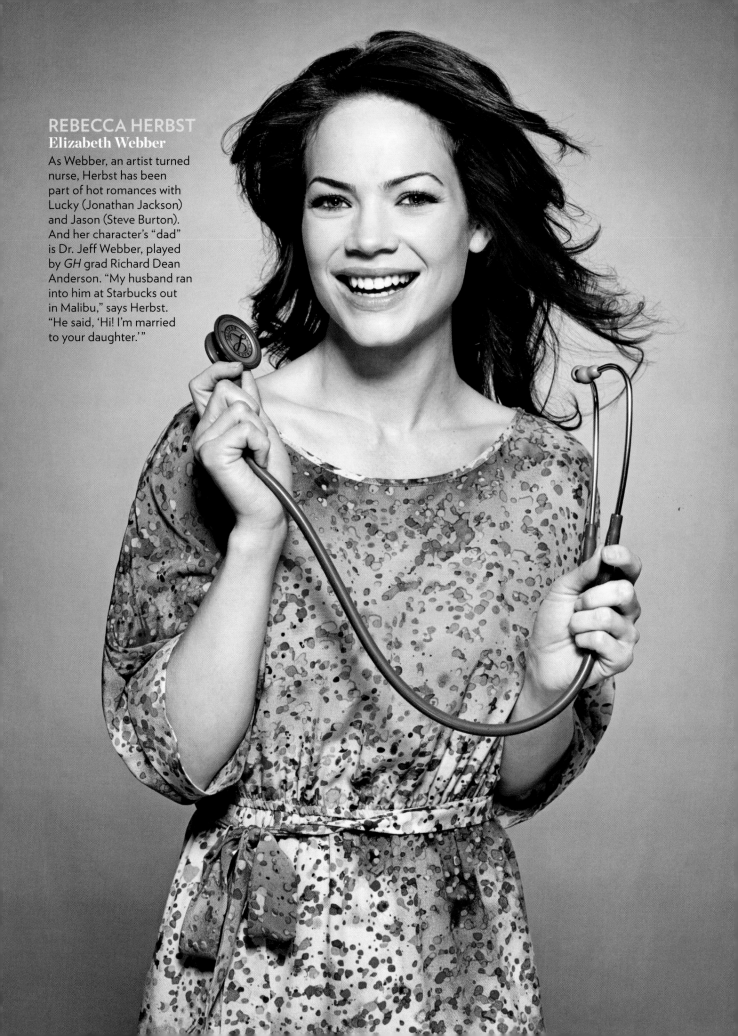

REBECCA HERBST
Elizabeth Webber

As Webber, an artist turned nurse, Herbst has been part of hot romances with Lucky (Jonathan Jackson) and Jason (Steve Burton). And her character's "dad" is Dr. Jeff Webber, played by *GH* grad Richard Dean Anderson. "My husband ran into him at Starbucks out in Malibu," says Herbst. "He said, 'Hi! I'm married to your daughter.'"

TEQUAN RICHMOND
T.J.

After a three-and-a-half year run on *Everybody Hates Chris*, the actor, who plays troubled teen Thomas "T.J." Ashford, joined *GH* and got a jolt. "Here you get one or two takes, tops," he says. "The actors don't miss a beat. In the film world, even the best actors aren't this sharp."

HALEY PULLOS
Molly Lansing

All of 14 years old, Pullos, who plays Alexis and Ric's daughter, gets tutored three hours a day on set and attends high school during weeks when the show is dark. At school, "if I'm like, 'Hey, what's up? I just got off work,' it sounds really weird," she says. "New friends are like, 'What?!' They're caught off-guard. Most kids don't work at 14, and I started at 10."

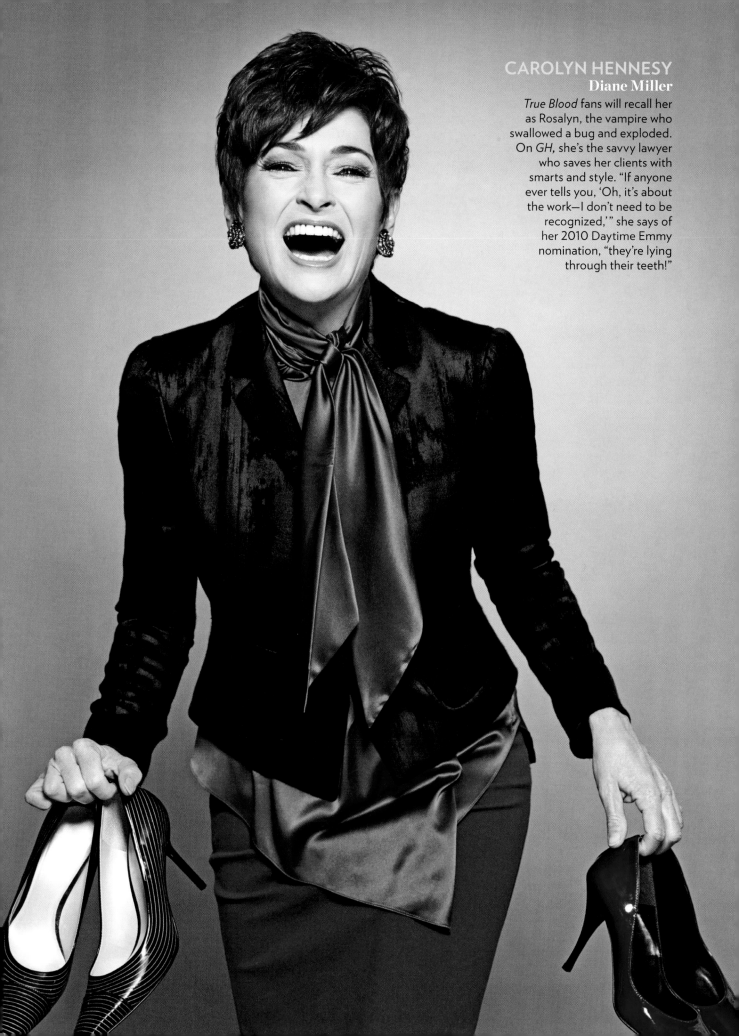

CAROLYN HENNESY
Diane Miller

True Blood fans will recall her as Rosalyn, the vampire who swallowed a bug and exploded. On *GH*, she's the savvy lawyer who saves her clients with smarts and style. "If anyone ever tells you, 'Oh, it's about the work—I don't need to be recognized,'" she says of her 2010 Daytime Emmy nomination, "they're lying through their teeth!"

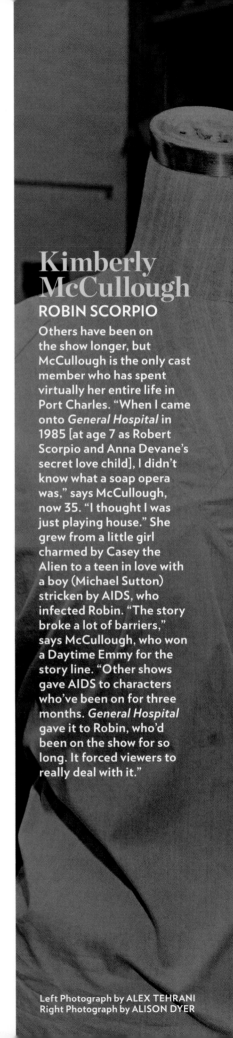

Kimberly McCullough
ROBIN SCORPIO

Others have been on the show longer, but McCullough is the only cast member who has spent virtually her entire life in Port Charles. "When I came onto *General Hospital* in 1985 [at age 7 as Robert Scorpio and Anna Devane's secret love child], I didn't know what a soap opera was," says McCullough, now 35. "I thought I was just playing house." She grew from a little girl charmed by Casey the Alien to a teen in love with a boy (Michael Sutton) stricken by AIDS, who infected Robin. "The story broke a lot of barriers," says McCullough, who won a Daytime Emmy for the story line. "Other shows gave AIDS to characters who've been on for three months. *General Hospital* gave it to Robin, who'd been on the show for so long. It forced viewers to really deal with it."

LYNN HERRING
Lucy Coe

Her 1986 gig as a mousy librarian in love with a killer was supposed to be short-term, but producers quickly realized fans loved Lucy and began linking her with a succession of men, including Jake, Tony and Alan. Herring's fave romance? "Scotty was Lucy's equal in hijinks and farce," she says, "but Kevin was her passion." Herring particularly enjoyed hosting the annual Nurses' Ball, which raised AIDS awareness. "The audience got to laugh and cry," she says. "That's when television is at its best, when it is creating art with a purpose."

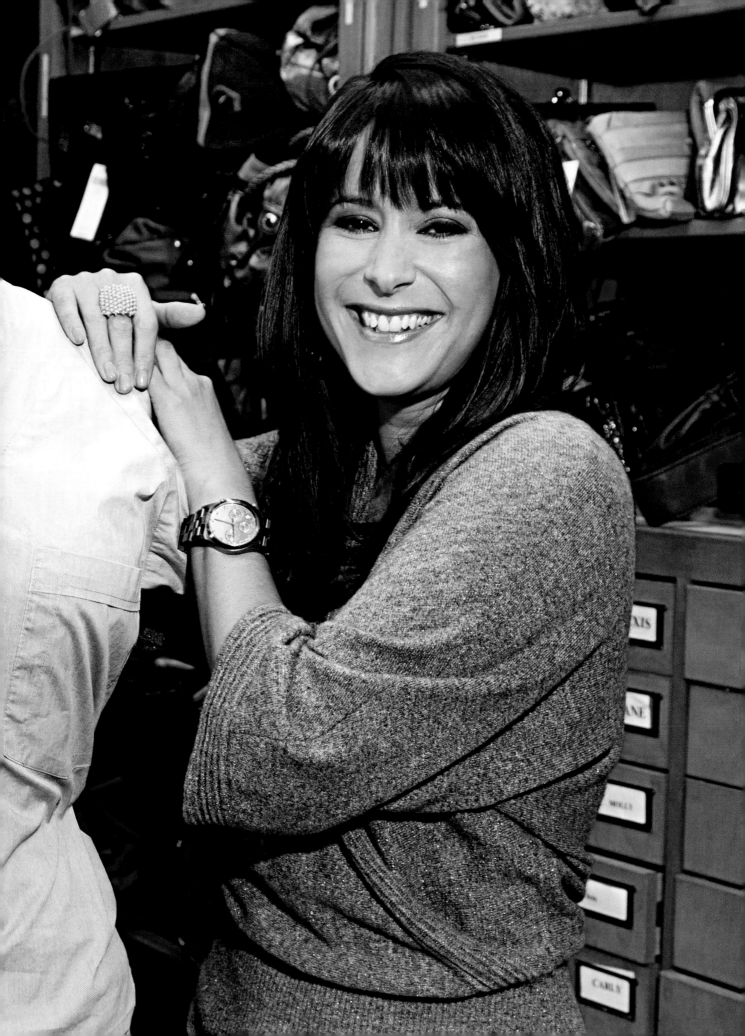

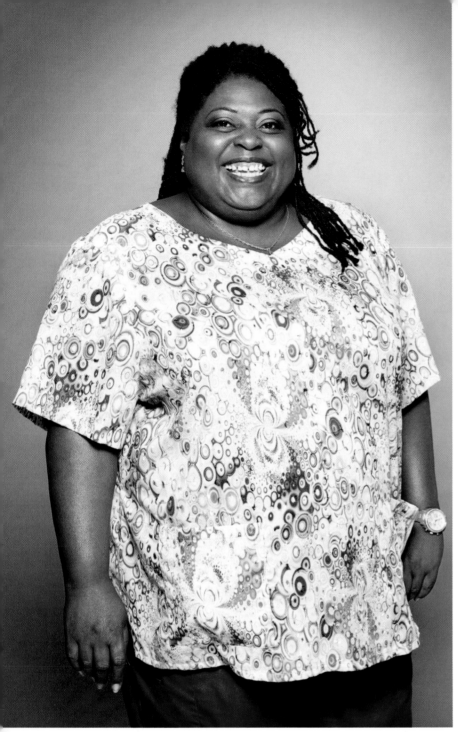

EMILY WILSON
Ellie Trout

"I was bummed out I didn't get the part," Wilson says of her failed audition for Sabrina last year. But producers liked her so much they created Ellie, the quirky lab tech, just for her—and named her Ellie after executive producer Frank Valentini's niece.

MICHAEL EASTON
John McBain

One Life to Live went off TV in 2012—but detective John McBain lived on, moving to Port Charles to discomfit the mob and send Sam McCall's heart aflutter. "It was sad to say goodbye to a show that I called home for eight years," he says. Some compensation: working again with Kelly Monaco, a friend from when they worked on *GH* spin-off *Port Charles* a decade ago. "Looking into those big brown eyes, it's like I never left."

SONYA EDDY
Epiphany Johnson

Hired in 2006 to play *GH*'s no-nonsense head nurse, Eddy sought advice from a friend who had a similar job in real life. "She said, 'I don't take orders from anybody whose license is younger than me!'" says the actress, who took that I'm-in-charge-here attitude to heart. "These people, they're all young and sexy, running into closets," she says of one of Epiphany's constant challenges. "I gotta beat them out with brooms. Come on! This is work, not romance central!" Asked about iconic *GH* nurse Jessie Brewer, Eddy makes clear that Epiphany would never put up with a philandering husband the way Brewer did. "Oh no, she wouldn't bother with that," says Eddy. "You'd come home and find all your stuff packed up on the lawn."

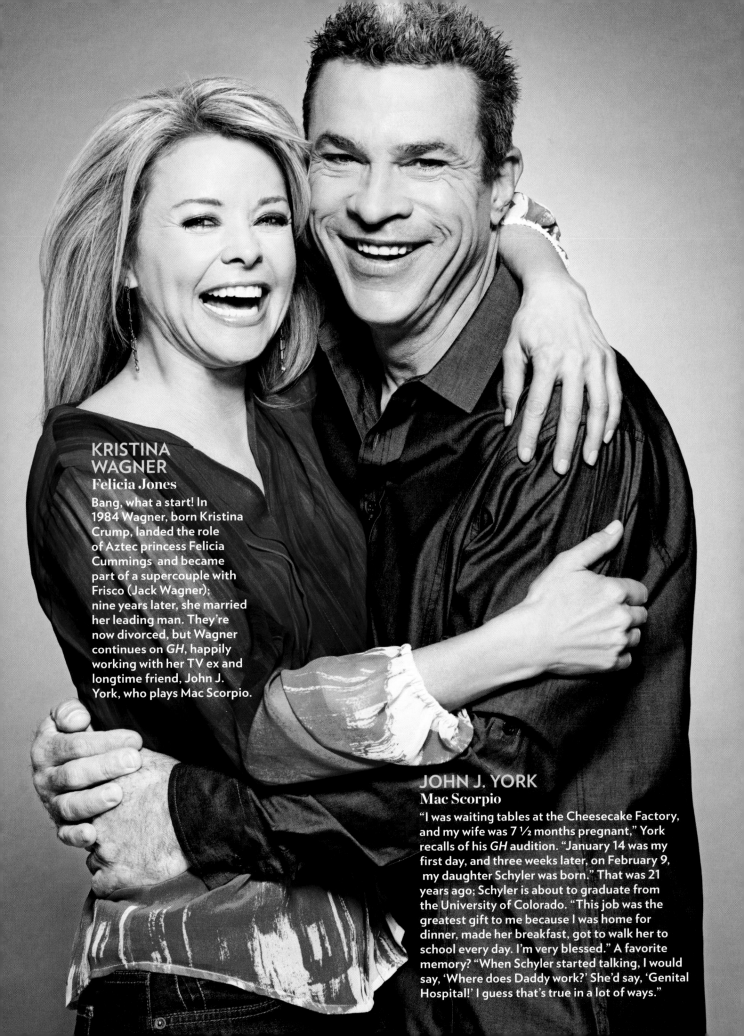

KRISTINA WAGNER
Felicia Jones

Bang, what a start! In 1984 Wagner, born Kristina Crump, landed the role of Aztec princess Felicia Cummings and became part of a supercouple with Frisco (Jack Wagner); nine years later, she married her leading man. They're now divorced, but Wagner continues on *GH*, happily working with her TV ex and longtime friend, John J. York, who plays Mac Scorpio.

JOHN J. YORK
Mac Scorpio

"I was waiting tables at the Cheesecake Factory, and my wife was 7 ½ months pregnant," York recalls of his *GH* audition. "January 14 was my first day, and three weeks later, on February 9, my daughter Schyler was born." That was 21 years ago; Schyler is about to graduate from the University of Colorado. "This job was the greatest gift to me because I was home for dinner, made her breakfast, got to walk her to school every day. I'm very blessed." A favorite memory? "When Schyler started talking, I would say, 'Where does Daddy work?' She'd say, 'Genital Hospital!' I guess that's true in a lot of ways."

Jane Elliot

TRACY QUARTERMAINE

When it comes to playing the Queen Bitch, Elliot set the bar high for herself. The genre's go-to conniver, she has worked her backstabbing magic in roles on *All My Children*, *Days of Our Lives*, *Knots Landing* and *Guiding Light*. (For that show she dialed it down a bit: Of her character's three personalities, only one was a villain.)

But fans agree that the soaps' reigning *femme chienne* is at her bitchin' best as *GH*'s double-crossing, no-account swindler with an unsettling father fixation. Her most black-hearted act? When, hoping to inherit millions, she withheld heart medicine from her dying, pleading dad, Edward (David Lewis). He soon revealed that he was faking illness to test her love (she failed). "David and I were completely committed to the reality of that scene," Elliot says. "It was so raw, intense and emotional we decided not to rehearse it. We hit the stage, did our dress rehearsal and then taped it."

Thirty years later *GH* referenced that memorable 1981 scene when Tracy gave her father (played by John Ingle) the sole antidote to the town's poisoned water supply, only to see him do her one better by selflessly giving it away. "That was great," Elliot says in praise of the current *GH* creative team. "I'm excited about what I'm being asked to do. I like the show. I'm enjoying watching the show. For me, this is what a soap opera is."

LISA LOCICERO
Olivia Falconeri

At 10, she wrote a fan letter to Tristan Rogers—then brought it with her when she auditioned for *GH* in '08. "Being on this show has a beautiful, full-circle element to it," she says. "There's an ongoing mythology in soap operas unlike any other type of media."

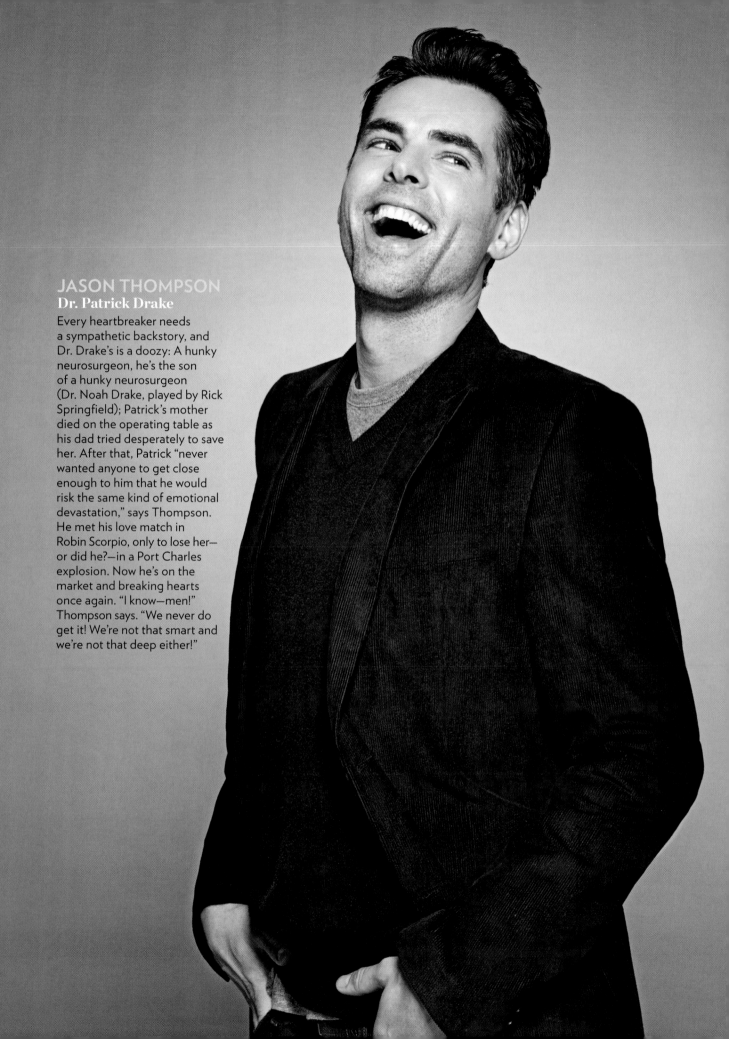

JASON THOMPSON
Dr. Patrick Drake

Every heartbreaker needs a sympathetic backstory, and Dr. Drake's is a doozy: A hunky neurosurgeon, he's the son of a hunky neurosurgeon (Dr. Noah Drake, played by Rick Springfield); Patrick's mother died on the operating table as his dad tried desperately to save her. After that, Patrick "never wanted anyone to get close enough to him that he would risk the same kind of emotional devastation," says Thompson. He met his love match in Robin Scorpio, only to lose her— or did he?—in a Port Charles explosion. Now he's on the market and breaking hearts once again. "I know—men!" Thompson says. "We never do get it! We're not that smart and we're not that deep either!"

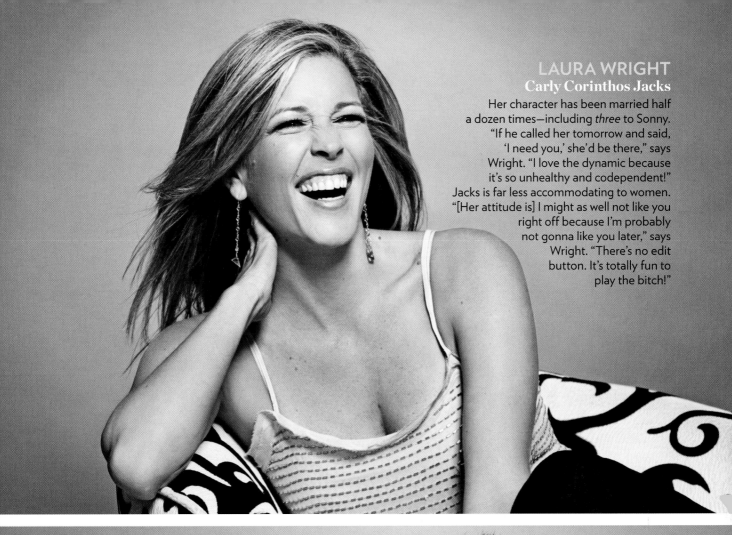

LAURA WRIGHT
Carly Corinthos Jacks

Her character has been married half a dozen times—including *three* to Sonny. "If he called her tomorrow and said, 'I need you,' she'd be there," says Wright. "I love the dynamic because it's so unhealthy and codependent!" Jacks is far less accommodating to women. "[Her attitude is] I might as well not like you right off because I'm probably not gonna like you later," says Wright. "There's no edit button. It's totally fun to play the bitch!"

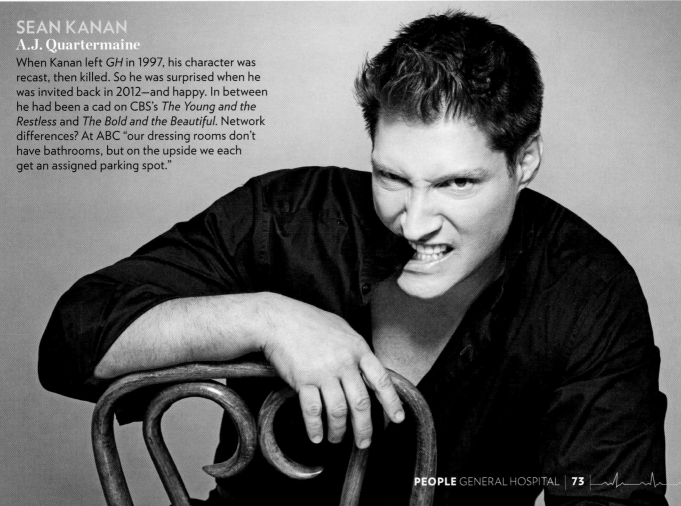

SEAN KANAN
A.J. Quartermaine

When Kanan left *GH* in 1997, his character was recast, then killed. So he was surprised when he was invited back in 2012—and happy. In between he had been a cad on CBS's *The Young and the Restless* and *The Bold and the Beautiful*. Network differences? At ABC "our dressing rooms don't have bathrooms, but on the upside we each get an assigned parking spot."

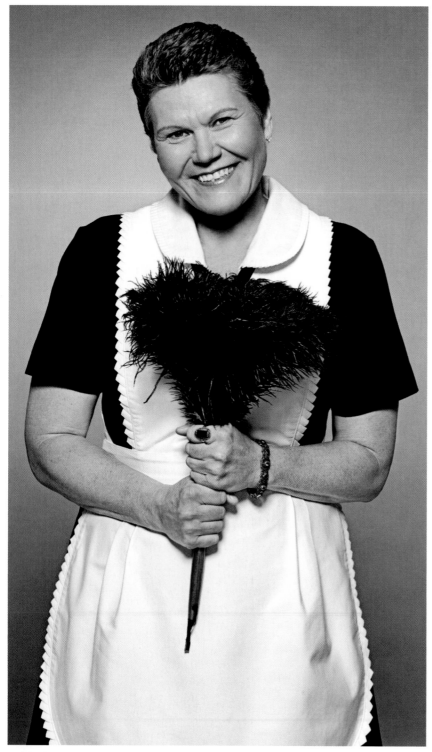

BERGEN WILLIAMS
Alice Gunderson

Hired in 2001 to play a cop posing as a maid, Williams was told her character would be killed off in 3 months. But the Sept. 11 terror attacks caused *GH* to scrap her cop plot, which involved chemical warfare—and 12 years later, she's still dusting. "In all this time no one has ever said anything about it to me!" marvels Williams, whose character moonlights as a wrestler called the Dominator. Williams doesn't wrestle in real life, though she notes, "I've played a lot of wrestlers on TV—that and German wax ladies."

Finola Hughes
ANNA DEVANE

"Gloria Monty brought me to her office and said she wanted me to watch a Joan Crawford movie called *A Woman's Face*," says Hughes of her introduction to the show in 1985. "She said, 'That's what we're going to do to you.'" "That" was a facial scar that Hughes's character would wear, a dermatological Scarlet Letter resulting from a mysterious betrayal in her past.

Then her character caught on—and writers decided to ditch the scar. In an only-in-soaps moment, Anna revealed that the scar was a fake, a kind of penance to remind herself that she had lost her husband by being a double agent. Of course.

A fan fave, Hughes won a Daytime Best Actress Emmy in 1991. She later joined *All My Children* for four years and was twice nominated for an Emmy— for playing her *GH*'s character's identical twin Alex Devane.

Although she had been linked with almost all the *GH* heartthrob heavyweights, including Scorpio and Duke, Anna is currently living with Luke and working as Port Charles's police commissioner.

"I love that the show allows her to screw up and be flawed," says Hughes. "I don't want to be cool all the time."

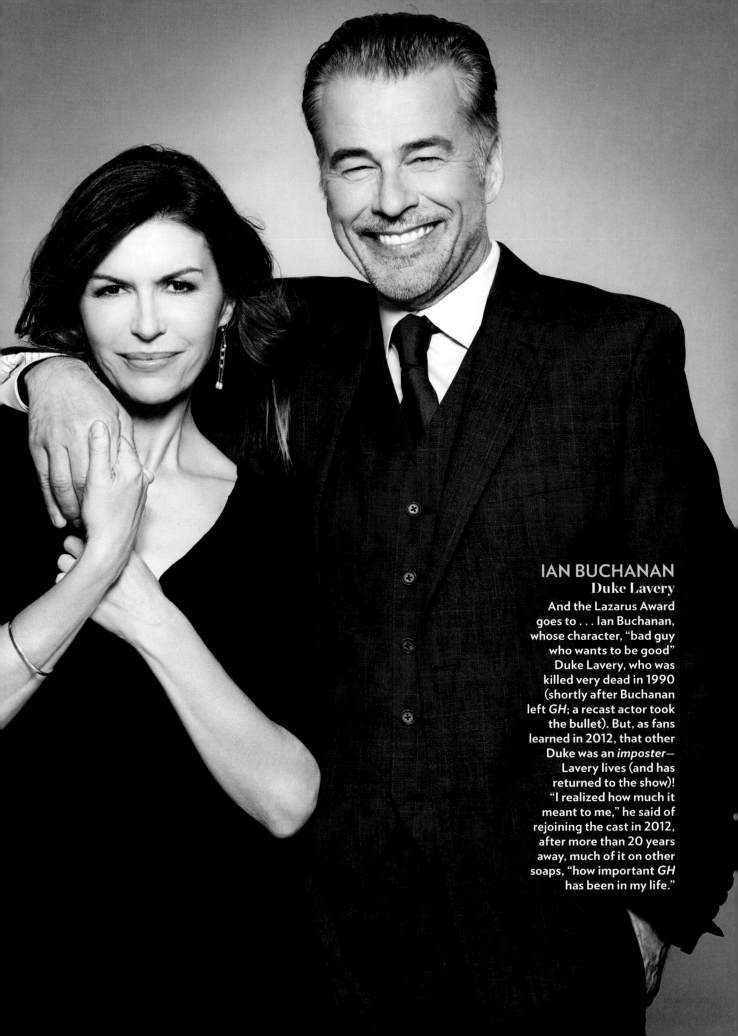

IAN BUCHANAN
Duke Lavery

And the Lazarus Award goes to . . . Ian Buchanan, whose character, "bad guy who wants to be good" Duke Lavery, who was killed very dead in 1990 (shortly after Buchanan left *GH*; a recast actor took the bullet). But, as fans learned in 2012, that other Duke was an *imposter—* Lavery lives (and has returned to the show)! "I realized how much it meant to me," he said of rejoining the cast in 2012, after more than 20 years away, much of it on other soaps, "how important *GH* has been in my life."

MARC ANTHONY SAMUEL
Felix DuBois

No closet for Felix: "It's really cool," Samuel says of his openly gay student-nurse alter-ego. "I'm honored to be able to represent an under represented group of people, and I hope I'm doing them proud."

SEAN BLAKEMORE
Shawn Butler

Playing a former Marine dealing with—among other things—post-traumatic stress, Blakemore was Emmy nominated his first year on *GH*. His more rueful claim to fame: For some reason, scripts call for him to take his shirt off. A lot. "It's not my choice!" he insists. "I didn't volunteer!"

TERESA CASTILLO
Sabrina Santiago

Wimp or wildcat? Fans are betting the timid newcomer will lose her specs, let her hair down and wow the dashing doc of her dreams. "I think probably that will happen, but you never know," she says.

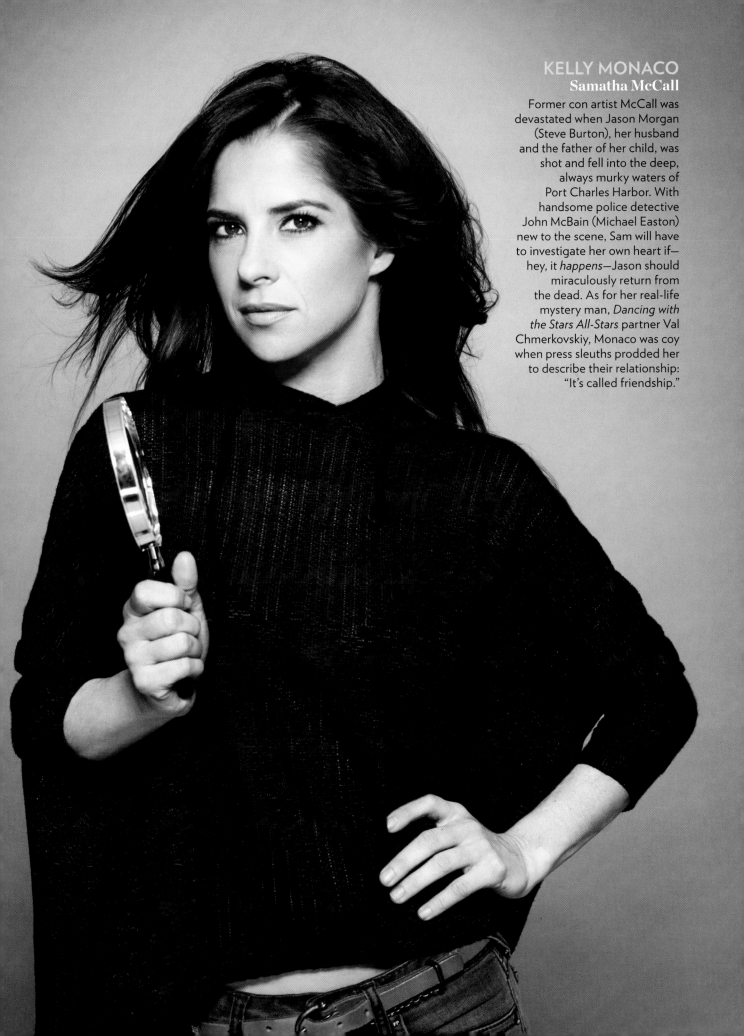

KELLY MONACO
Samatha McCall

Former con artist McCall was devastated when Jason Morgan (Steve Burton), her husband and the father of her child, was shot and fell into the deep, always murky waters of Port Charles Harbor. With handsome police detective John McBain (Michael Easton) new to the scene, Sam will have to investigate her own heart if— hey, it *happens*—Jason should miraculously return from the dead. As for her real-life mystery man, *Dancing with the Stars All-Stars* partner Val Chmerkovskiy, Monaco was coy when press sleuths prodded her to describe their relationship: "It's called friendship."

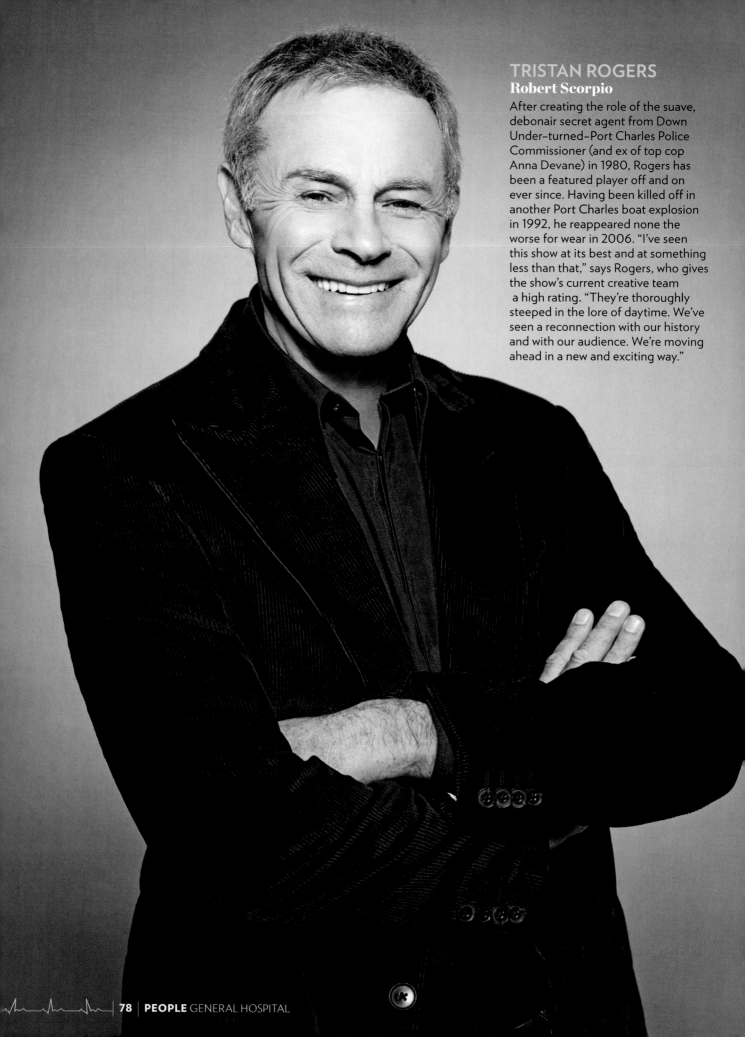

TRISTAN ROGERS
Robert Scorpio

After creating the role of the suave, debonair secret agent from Down Under–turned–Port Charles Police Commissioner (and ex of top cop Anna Devane) in 1980, Rogers has been a featured player off and on ever since. Having been killed off in another Port Charles boat explosion in 1992, he reappeared none the worse for wear in 2006. "I've seen this show at its best and at something less than that," says Rogers, who gives the show's current creative team a high rating. "They're thoroughly steeped in the lore of daytime. We've seen a reconnection with our history and with our audience. We're moving ahead in a new and exciting way."

KELLY SULLIVAN
**Connie Falconeri/
Kate Howard**

Beginning in 2011, Kelly snagged one of the best assignments in soaps: a split personality (the next best thing, perhaps, to an Evil Twin). Kate is proud and sophisticated; Connie outlandish. "I know everybody says they have the best job, but I truly do," says Sullivan. "I try to have as much fun as I can playing these parts, because if I don't it's not going to work." On *GH,* her character Connie has written a book, *Love in Maine,* that will be part of a story line and also available, as a real book, in stores.

KELLY THIEBAUD
Dr. Britt Westbourne

One of *GH*'s newest hires— she joined in September 2012—Thiebaud is thrilled that she gets to play a rhymes-with-witch doctor. "She's a lot more vocal than I am," says Thiebaud. Bonus: "Grandma finally has a doctor in the family! My family's really proud of me."

Say what you will
about passion, plots, scripts,
drama, sets and stagecraft:
Soaps wouldn't be soaps without
a little Afternoon Delight

(Hot Guys)

STEVE BURTON
Jason Morgan

"I'd change my nose—and I hate my smile!" Burton once said (despite having his mug grace the cover of a 1994 coffee table book called *Perfect Face*). Remarkably, it took his character a long time to get lucky on *GH*: Three years in, he lamented, "I'm the last millionaire virgin on daytime!"

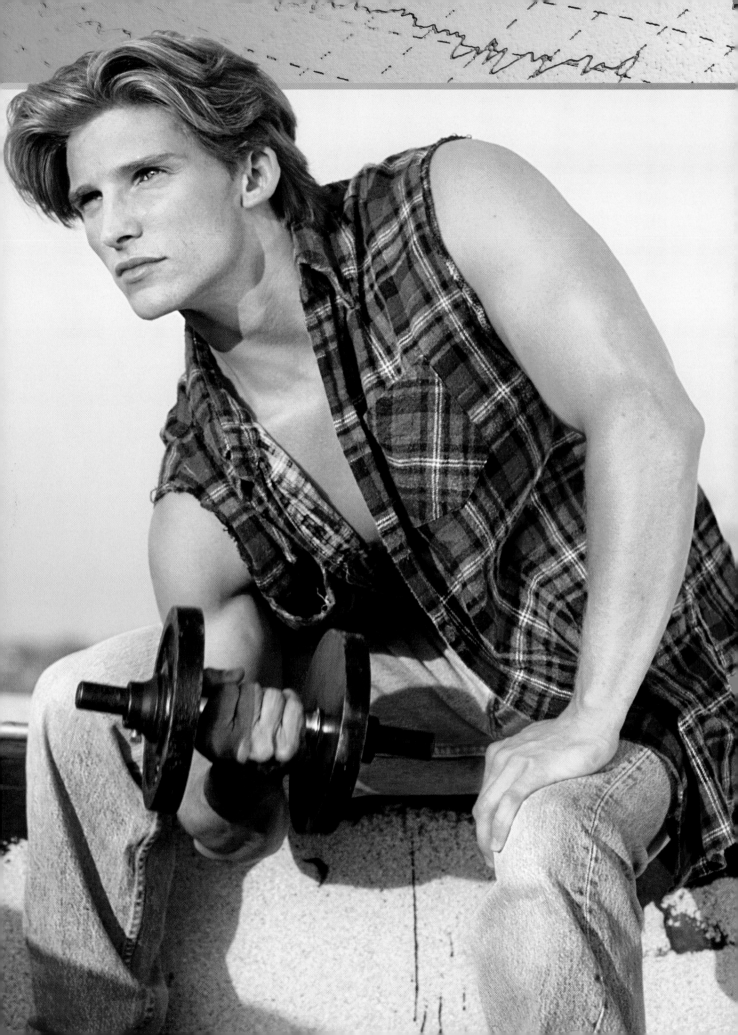

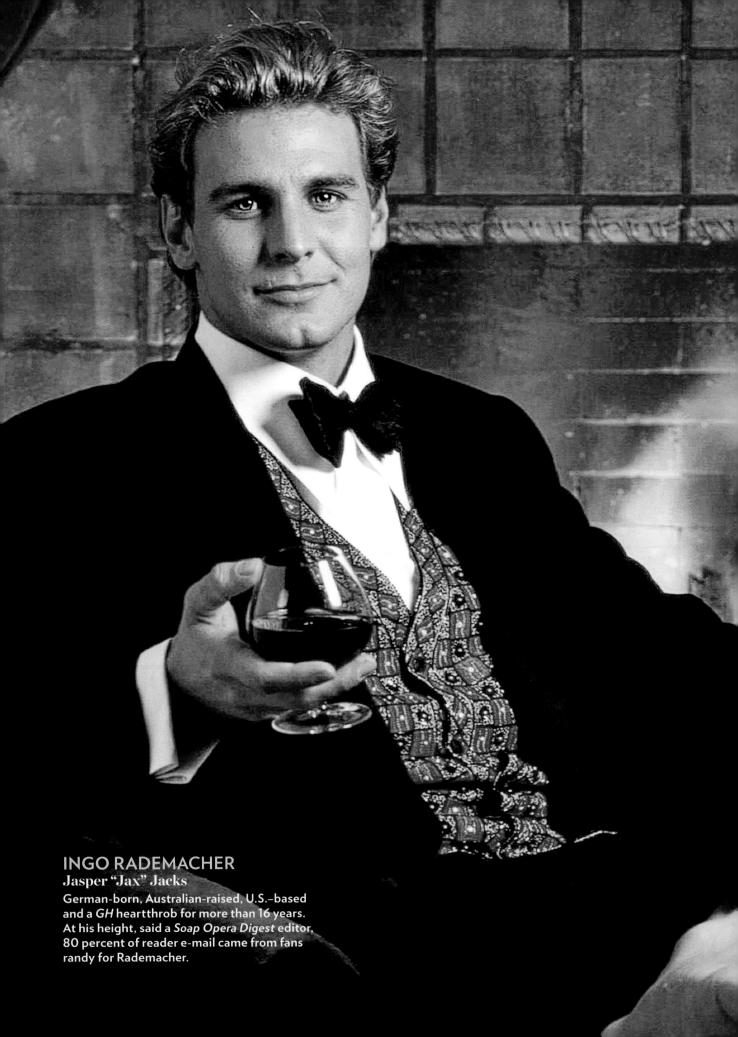

INGO RADEMACHER
Jasper "Jax" Jacks
German-born, Australian-raised, U.S.–based
and a *GH* heartthrob for more than 16 years.
At his height, said a *Soap Opera Digest* editor,
80 percent of reader e-mail came from fans
randy for Rademacher.

SAM BEHRENS
Jake Meyer

A measure of the Behrens Effect? After actress Shari Belafante turned down a role in a film, *Murder by Numbers*, the director asked her to come back and read with Behrens. "I'm there to say, 'No, thanks,'" she told PEOPLE, "but after I met Sam, I said, 'We start Monday?'" They've been married for 23 years.

RICHARD DEAN ANDERSON
Dr. Jeff Webber

Before he became MacGyver, Anderson was handsome Dr. Webber for five years. "I couldn't do [a soap] today if I wanted to," he said years later. "It's the hardest work."

RICK HEARST
Ric Lansing

Hearst won two Daytime Emmys as ruthless District Attorney Lansing, whom he has described as a "troubled, beguiling, messed-up, passionate, loving psychopath." Sigh. What more could a girl want?

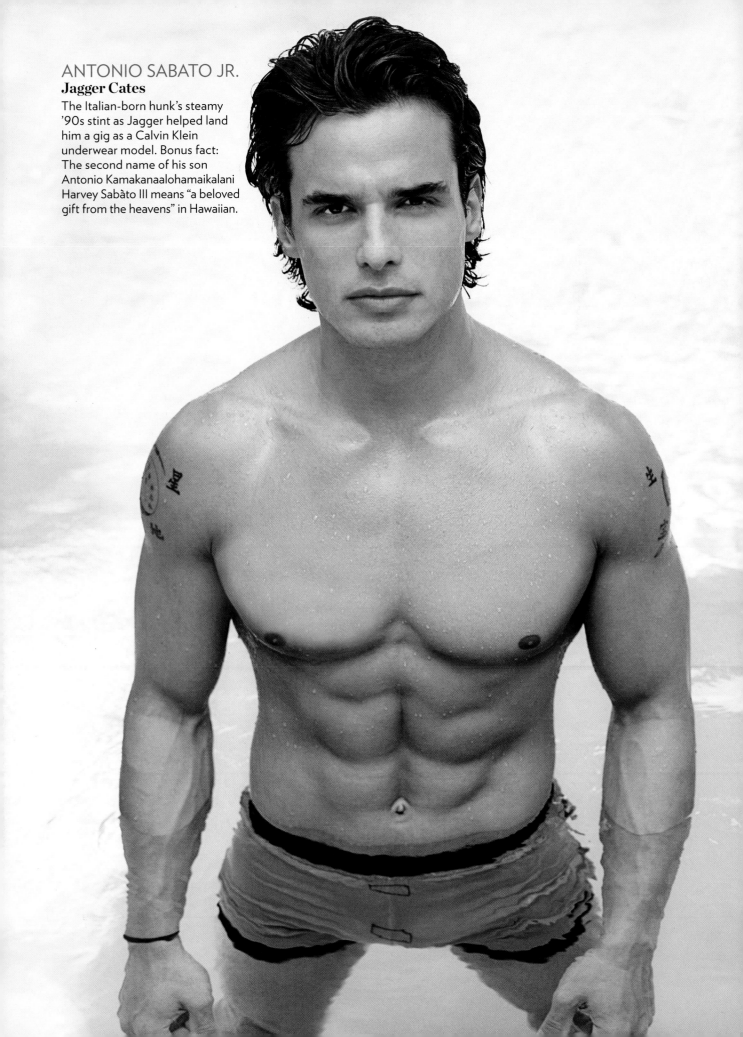

ANTONIO SABATO JR.
Jagger Cates

The Italian-born hunk's steamy '90s stint as Jagger helped land him a gig as a Calvin Klein underwear model. Bonus fact: The second name of his son Antonio Kamakanaalohamaikalani Harvey Sabàto III means "a beloved gift from the heavens" in Hawaiian.

CHRIS ROBINSON
Dr. Rick Webber

The studly supersurgeon was a cut above: So convincing was his bedside manner that Vicks Formula 44 hired him for the original "I'm not a doctor, but I play one on TV" commercial in 1984.

KIN SHRINER
Scotty Baldwin

The blond muscleman, who has done multiple stints on *GH* and one on a spin-off, has a real-life non-evil twin: comedian-director Wil Shriner, who is 8 minutes younger. "Those," Kin once told PEOPLE, "were the happiest 8 minutes of my life."

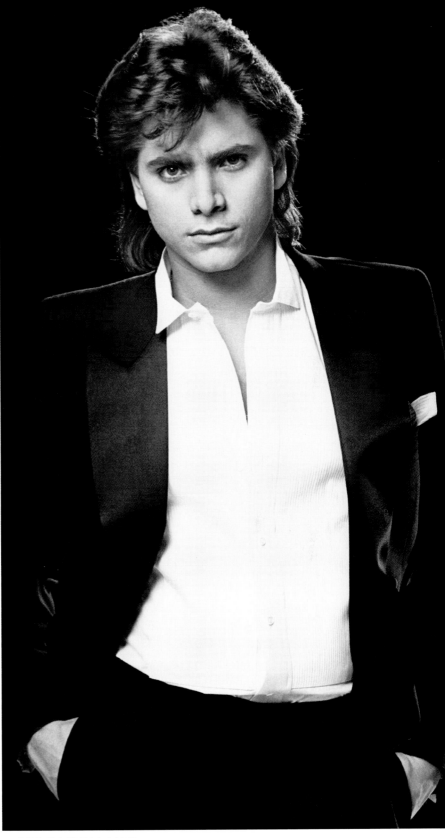

JOHN STAMOS
Blackie Parrish

"If I'm anywhere, it's because of *General Hospital*," the former *GH* (1982-1984) and *Full House* star has said. "I'll never stop appreciating what *GH* meant to me." As for that '80s shag: "It's almost like a dead crow was on my head."

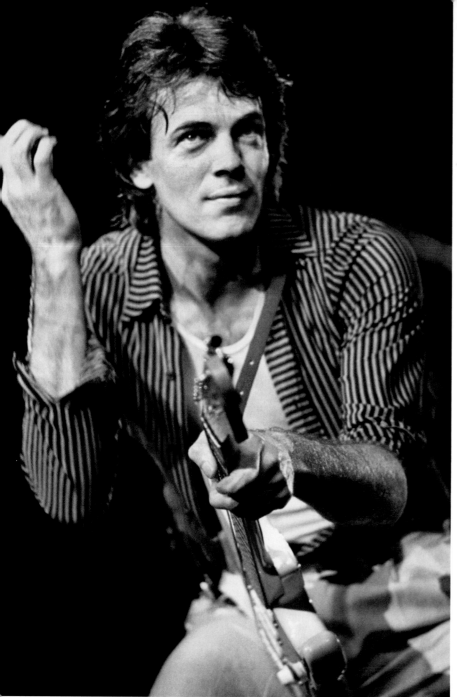

STEVE BOND
Jimmie Lee Holt
Born Schlomo Goldberg, Bond got in trouble during his '80s *GH* stint when old photos surfaced of him au naturel in *Playgirl.* "I was devastated," he said then. "It's my deepest, darkest secret." Producers, unamused, cut back his scenes, but his popularity saved him.

STUART DAMON
Dr. Alan Quartermane
He was the the hospital's pill-popping Chief of Staff for more than 30 years, leaving the show on his 70th birthday in 2007. But not really really: Longtime fans were so upset by his departure that producers have brought him back, occasionally, as a ghost and also in fantasy sequences.

RICK SPRINGFIELD
Dr. Noah Drake
A successful rocker in his native Australia, Springfield signed on to *GH* in 1981 just before his single "Jessie's Girl" became a worldwide hit and earned him a Grammy. He fretted, he told PEOPLE, about how soap stardom might affect his "credibility as a musician" until he found out that many deejays and at least one music legend, Beach Boy Brian Wilson, were *GH* addicts. Springfield left the show in 1983 then reprised his role 22 years later. Despite temptation, he wrote in his autobiography, *Late, Late at Night: A Memoir,* he never became involved with anyone on *GH*— "apart from a brief, erotic moment in front of a dressing room mirror with Demi Moore (sorry, she was just too hot)."

Amazing Coincidence: Rock star Eli Love so closely resembles Dr. Drake that when the rocker could not appear at a LifeBEAT charity concert in Port Charles, Dr. Drake appeared in his place! (Incredibly in that same 2007 episode, Rick Springfield sang on camera for the first time in his *GH* career.)

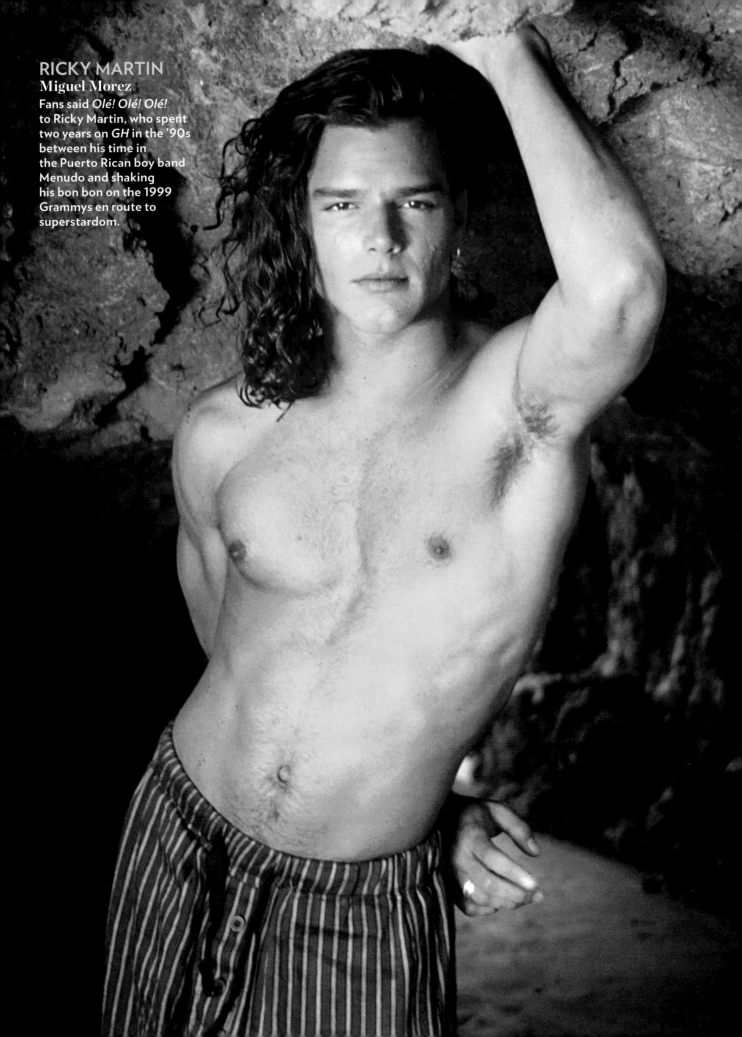

RICKY MARTIN
Miguel Morez
Fans said *Olé! Olé! Olé!* to Ricky Martin, who spent two years on *GH* in the '90s between his time in the Puerto Rican boy band Menudo and shaking his bon bon on the 1999 Grammys en route to superstardom.

Who knows what evil lurks
in the hearts of men (and women)
better than *General Hospital* viewers?
The show's rogues gallery includes
supercriminals, psycho killers and scary
guys and gals of every stripe.
Word of advice to baddies: If you're
blown up or shot down, don't despair—
you'll probably be back

(Villains)

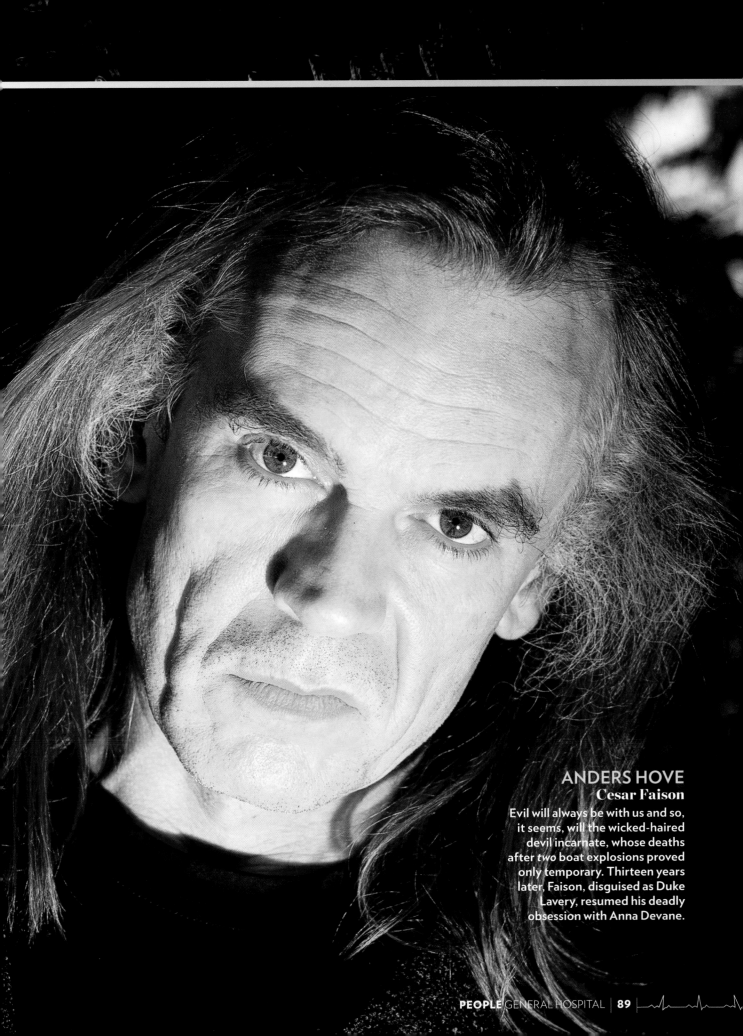

ANDERS HOVE
Cesar Faison
Evil will always be with us and so, it seems, will the wicked-haired devil incarnate, whose deaths after *two* boat explosions proved only temporary. Thirteen years later, Faison, disguised as Duke Lavery, resumed his deadly obsession with Anna Devane.

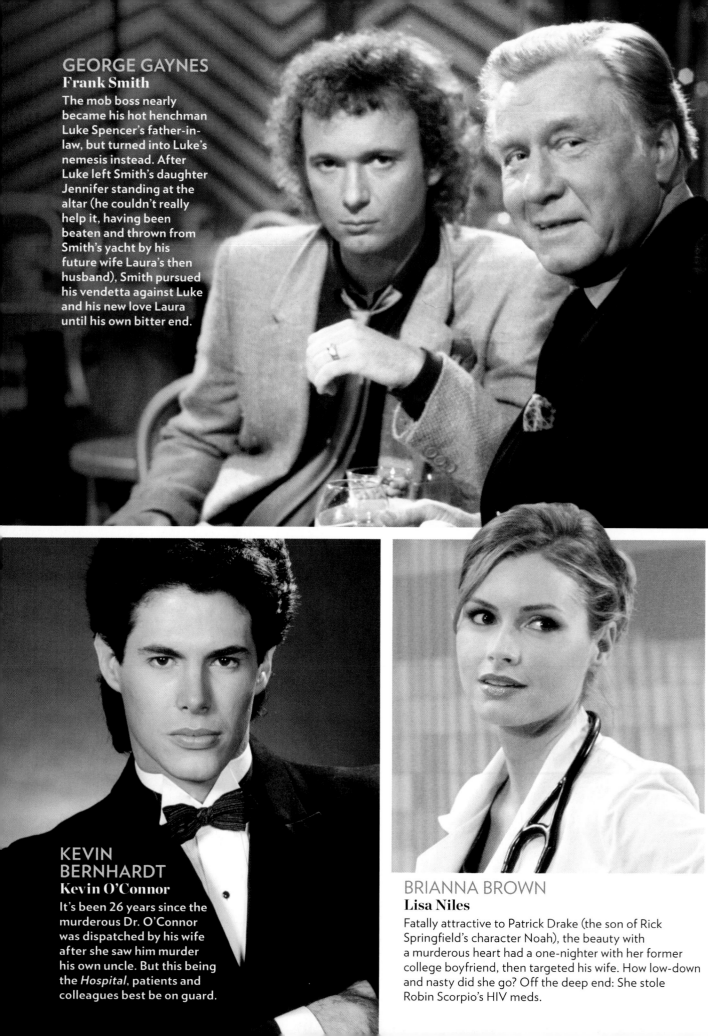

GEORGE GAYNES
Frank Smith

The mob boss nearly became his hot henchman Luke Spencer's father-in-law, but turned into Luke's nemesis instead. After Luke left Smith's daughter Jennifer standing at the altar (he couldn't really help it, having been beaten and thrown from Smith's yacht by his future wife Laura's then husband), Smith pursued his vendetta against Luke and his new love Laura until his own bitter end.

KEVIN BERNHARDT
Kevin O'Connor

It's been 26 years since the murderous Dr. O'Connor was dispatched by his wife after she saw him murder his own uncle. But this being the *Hospital*, patients and colleagues best be on guard.

BRIANNA BROWN
Lisa Niles

Fatally attractive to Patrick Drake (the son of Rick Springfield's character Noah), the beauty with a murderous heart had a one-nighter with her former college boyfriend, then targeted his wife. How low-down and nasty did she go? Off the deep end: She stole Robin Scorpio's HIV meds.

SEBASTIAN ROCHÉ
Jerry Jacks

Having survived deaths by drowning and by dynamite, Jacks masterminded a hostage takeover at the luxury hotel owned by his own brother and spiked the town's drinking water with a deadly toxin.

BRUCE WEITZ
Anthony Zacchara

Most evil deed? When the mob patriarch and certified lunatic kidnapped his own daughter and strapped her to a bomb, it was just par for the course.

JOHN COLICOS
Mikkos Cassadine

Descendant of Russian nobility, the crime patriarch took a page from Kruschev with his We Will Bury You (in-ice-and-snow) plot to control the weather. The man who saved the world from Cassadine and his weather machine? Luke Spencer, of course.

CYNTHIA PRESTON
Faith Rosco

Murder by lap dance is but one of the myriad methods—poison and snakes are among the others—that the black widow used to exact revenge on Sonny Corinthos for the murder of her husband.

TED KING
Lorenzo Alcazar

In a remarkable career arc, the former Oxford University prof turned shady international arms dealer arrived in Port Charles to seek revenge for the death of his brother Luis (also played by King), who was pushed off his penthouse balcony by soon-to-be D.A. Alexis Davis.

PIERCE DORMAN
Tuc Watkins

The Face of Weasel: His road to moral ruin began when he refused to operate on an AIDS victim. When he sued an ex-lover for sexual harassment, he convinced another old flame to lie on the stand. He then conned a vulnerable nurse into drugging Sonny Corinthos to make it look like an overdose—then murdered the nurse to cover his tracks. Add to his Mr. Nice Guy résumé his role as Port Charles's No. 1 importer of heroin. His favorite stash for the killer drug? General Hospital's morgue.

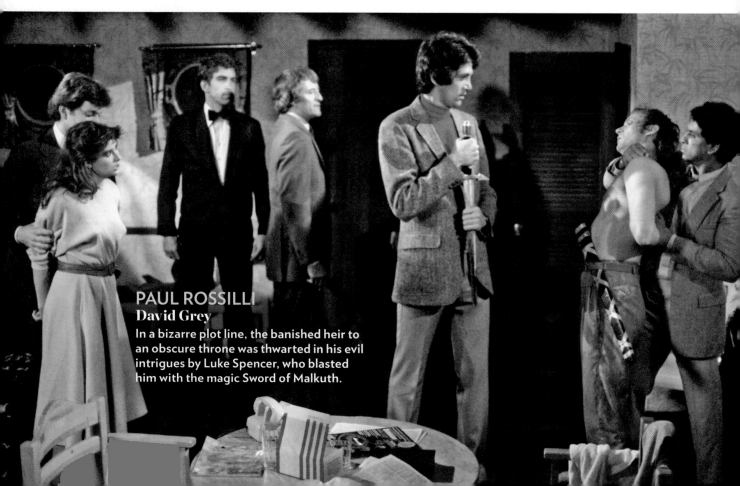

PAUL ROSSILLI
David Grey

In a bizarre plot line, the banished heir to an obscure throne was thwarted in his evil intrigues by Luke Spencer, who blasted him with the magic Sword of Malkuth.

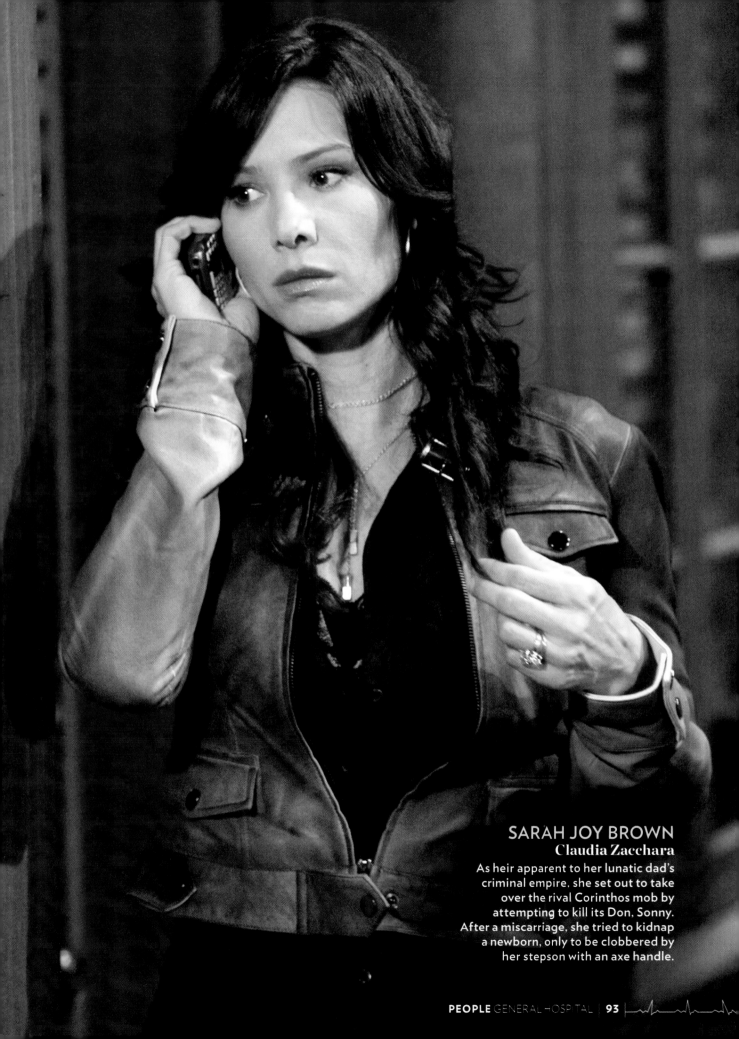

SARAH JOY BROWN
Claudia Zacchara

As heir apparent to her lunatic dad's criminal empire, she set out to take over the rival Corinthos mob by attempting to kill its Don, Sonny. After a miscarriage, she tried to kidnap a newborn, only to be clobbered by her stepson with an axe handle.

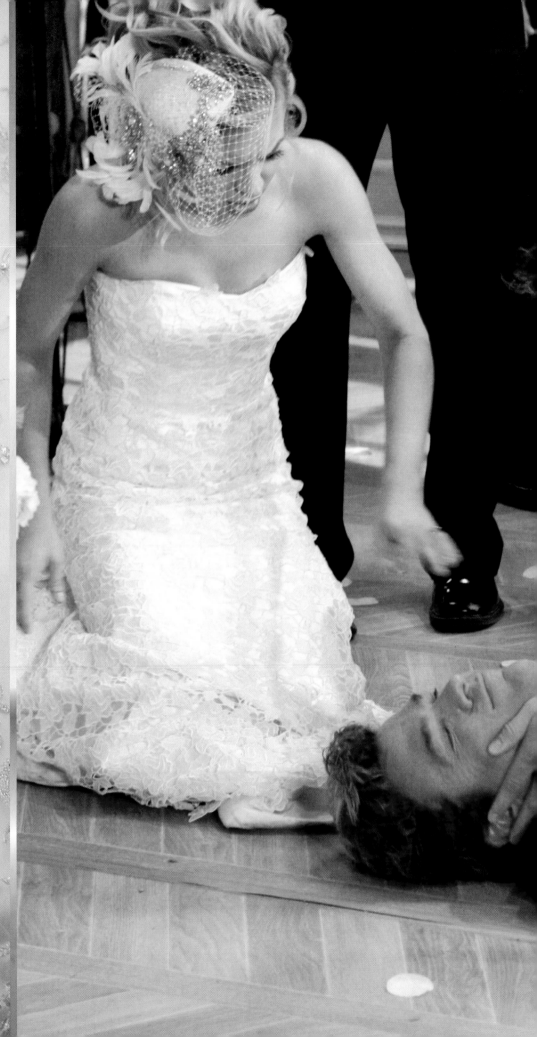

MAXIE & SPINELLI
Kirsten Storms and Bradford Anderson

In the *non*-wedding of the (*GH*'s half-) century, Maria Maximilliana Jones and her beau exchanged vows—to *not* marry. Matters of the heart had been troublesome for Maxie ever since her own ticker was transplanted at age 4. The mutual decision to neither have nor hold also came as a big relief to her adoptive dad, Mac Scorpio (John J. York) who fainted with joy (right).

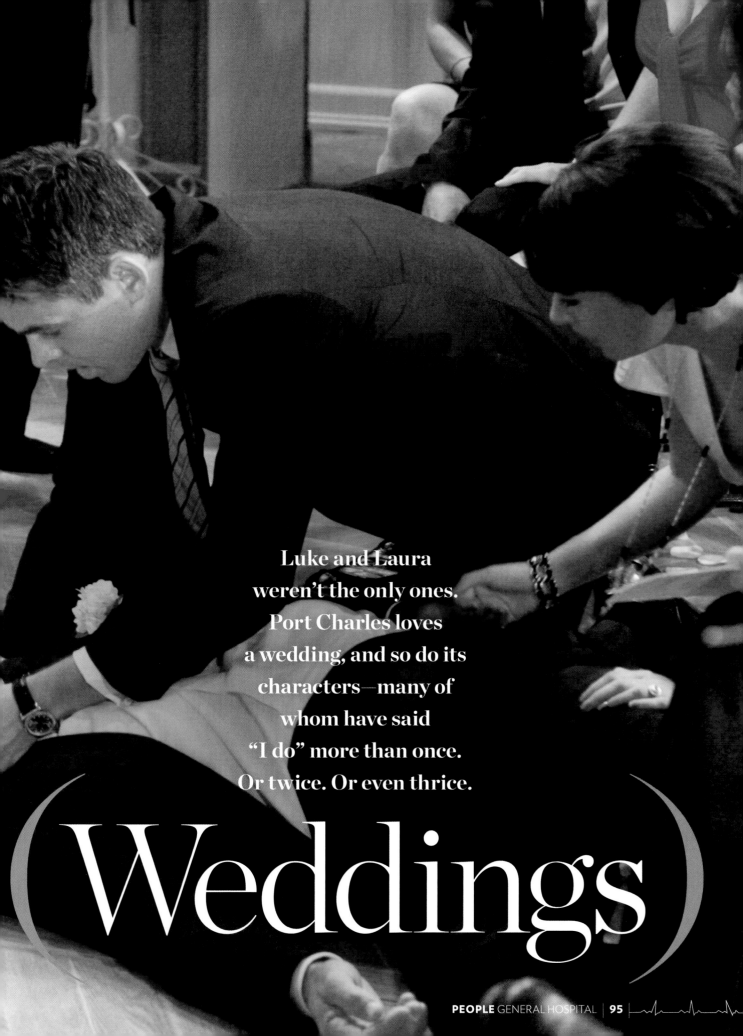

Luke and Laura
weren't the only ones.
Port Charles loves
a wedding, and so do its
characters—many of
whom have said
"I do" more than once.
Or twice. Or even thrice.

(Weddings)

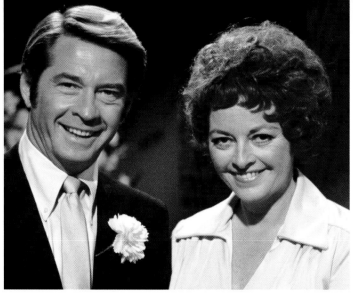

PETER & JESSIE
Craig Huebing and Emily McLaughlin

Nurse Jessie and Dr. Peter Taylor's nuptials were undone by that curse of soap opera love, the "dead" husband who, it turns out, inconveniently isn't.

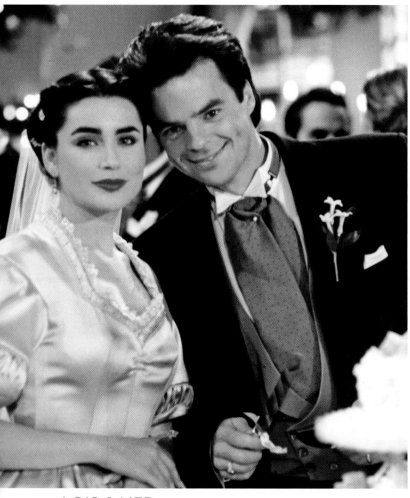

LOIS & NED
Rena Sofer and Wally Kurth

For a guy who does everything in pairs—two identities, two careers, two wives—it made sense when Ned, corporate raider and rock singer, married his one true love for a second time, in 1995.

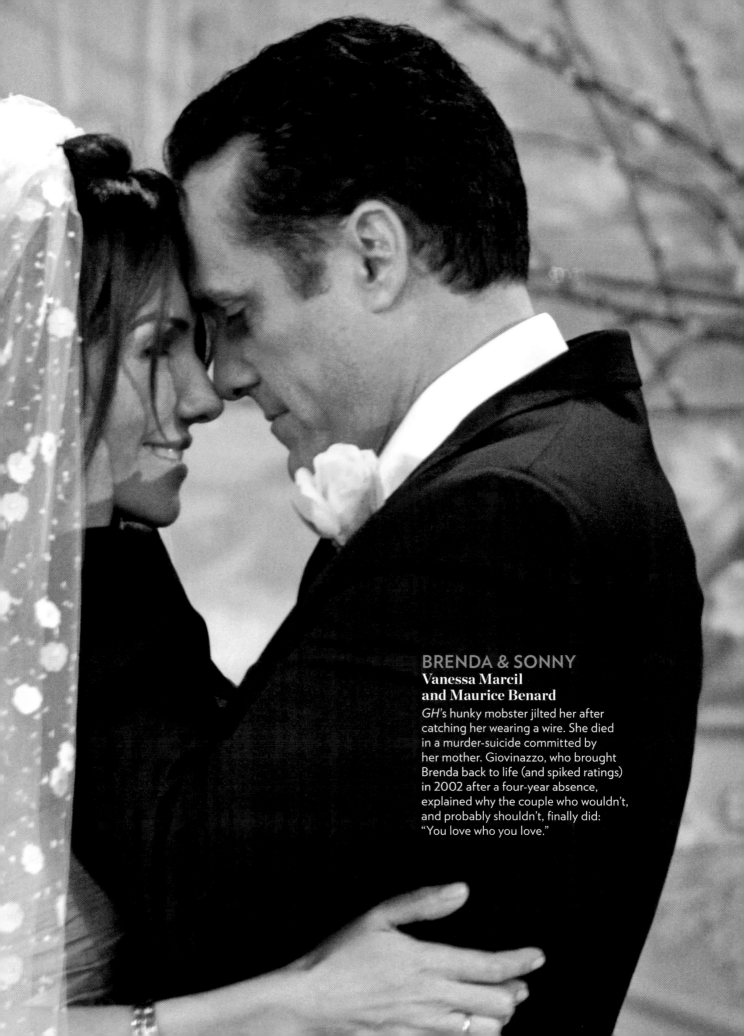

BRENDA & SONNY
**Vanessa Marcil
and Maurice Benard**

GH's hunky mobster jilted her after catching her wearing a wire. She died in a murder-suicide committed by her mother. Giovinazzo, who brought Brenda back to life (and spiked ratings) in 2002 after a four-year absence, explained why the couple who wouldn't, and probably shouldn't, finally did: "You love who you love."

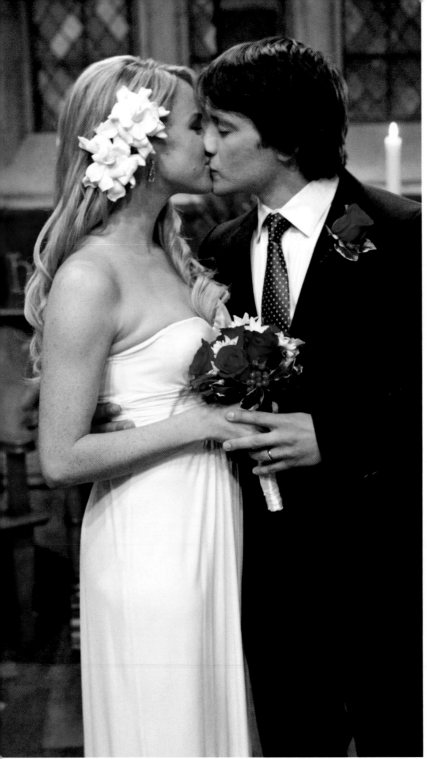

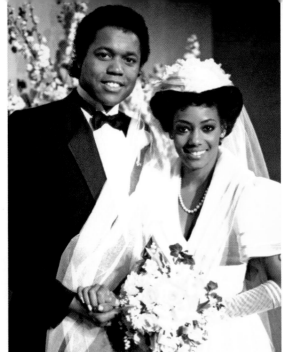

BRYAN & CLAUDIA
Todd Davis and Bianca Ferguson
After four years of indecision—and his fiancée's accidental poisoning—businessman Bryan Phillips finally put a ring on Claudia Johnston in 1983.

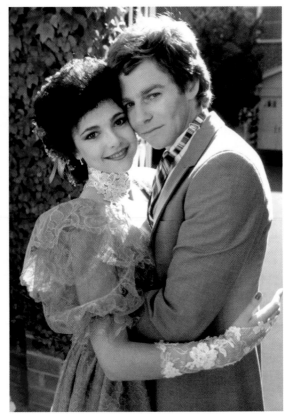

LULU & DANTE
Julie Berman and Dominic Zamprogna
As if the wedding of *GH* princess Lulu Spencer—as the daughter of Luke and Laura, she's soap royalty—and mob-busting-detective-with-father-issues Dante Falconeri wasn't enough to get fans choked up, the December 2011 episode followed the couple to Ground Zero on Christmas Eve. When Dante shared his memories of the trauma he experienced 10 years before, the outpouring washed away the couple's doubts and they decided to wed the very next day. A pity they were alone in a strange city on Christmas Day, right? Not if you're *Hospital*ized: Dante's cousin Tommy was a priest, and his sainted mother, Olivia, enlisted the the whole Falconeri clan to surprise the couple at their nuptials.

HOLLY & ROBERT
Emma Samms and Tristan Rogers
They married for a green card—Holly was to be deported after the avalanche "death" of fiancé Luke Spencer, the father of her unborn child—but love ensued.

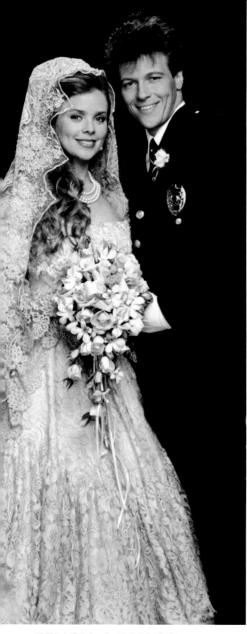

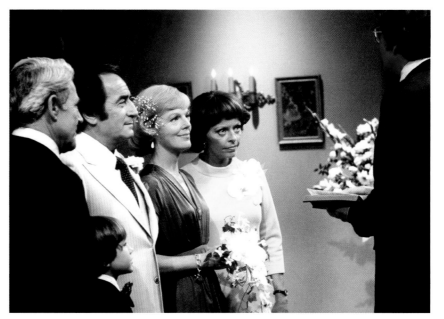

AUDREY & STEVE
Rachel Ames and John Beradino

With two weddings, one divorce, a remarriage made necessary when a supposedly dead husband came back from the grave, two miracle cures (his paralysis; her lymphoma) and a secret love child (hers) packed among their collective baggage, Dr. Steve Hardy and true love Audrey March set the template for all who came after them.

FELICIA & FRISCO
Kristina Malandro and Jack Wagner

She was an Aztec princess, disguised as a sneak thief, in search of lost treasure; he was a rock-and-roller about to become a spy. *Of course they fell in love!* Their wedding was a 1986 highlight, but soon Frisco joined the World Security Bureau and was sent away on a secret assignment—never to be seen again! Devestated, Felicia found consolation and, eventually, love with handsome newcomer Colton Shore. But wait! Frisco, whose life had been in danger, was alive and hiding in Port Charles's seldom-discussed catacombs! When he emerged and called her name, Felicia fainted; after more drama, they rewed in 1990.

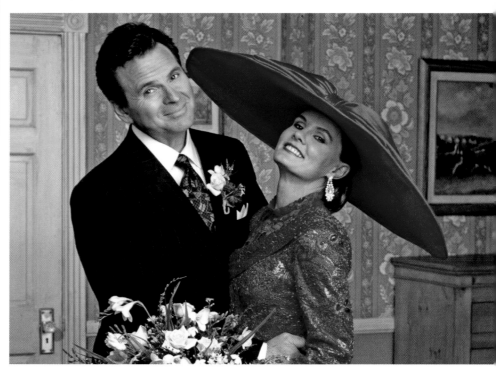

ALAN & LUCY
Stuart Damon and Lynn Herring

The bride wore red: When social climber Lucy Coe scored a date at the altar with *General Hospital*'s wealthy Dr. Alan Quartermaine (who was married to another when she first lured him to bed), she intended to waltz down the aisle in a virginal white wedding gown. But when the scarlet-for-harlot number was sent by mistake, she proudly scandalized the gathered cream of Port Charles society.

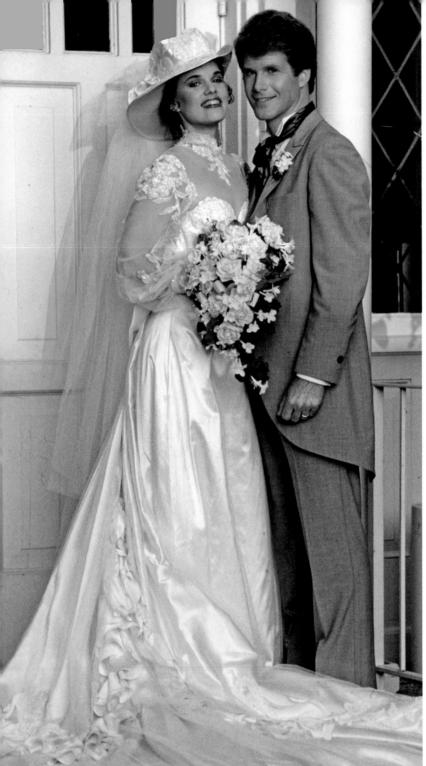

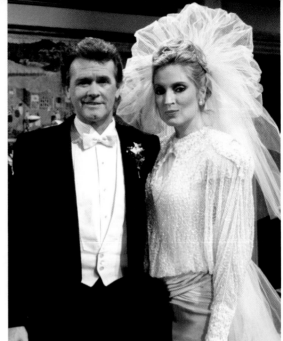

SEAN & TIFFANY
John Reilly and Sharon Wyatt
After Port Charles's upstanding former Police Commissioner dragged his sexy white-trash bride (née Elsie May Krumholtz) to the altar, they lived happily but not, of course, ever after.

CELIA & GRANT
Sherilyn Wolter and Brian Patrick Clarke
Orthopedic surgeon Dr. Grant Putnam was not what he seemed; but then his bride, a daughter of the powerful Quartermaine clan, wasn't exactly a dutiful fiancée. After rolling in the arms and bed of her supposedly ex-boyfriend Jimmy Lee Holt throughout her engagement to Grant, Celia was kidnapped on her wedding day by the spurned Jimmy Lee. She managed to escape his clutches and hitched a ride to her wedding in the back of a chicken truck. In the end, Jimmy Lee won Celia's hand, after Grant was exposed as an imposter sent by the sinister DVX crime cartel to steal the top secret Prometheus Disk.

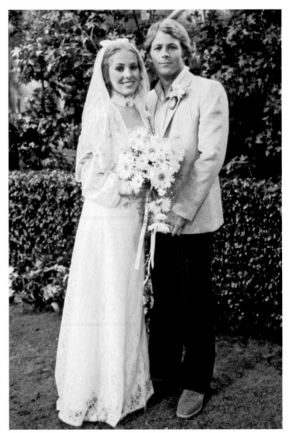

LAURA & SCOTTY
Genie Francis and Kin Shriner
Before she married that Other Guy—but after killing scheming artist David Hamilton—Laura overcame hurdles to wed Scotty in 1979.

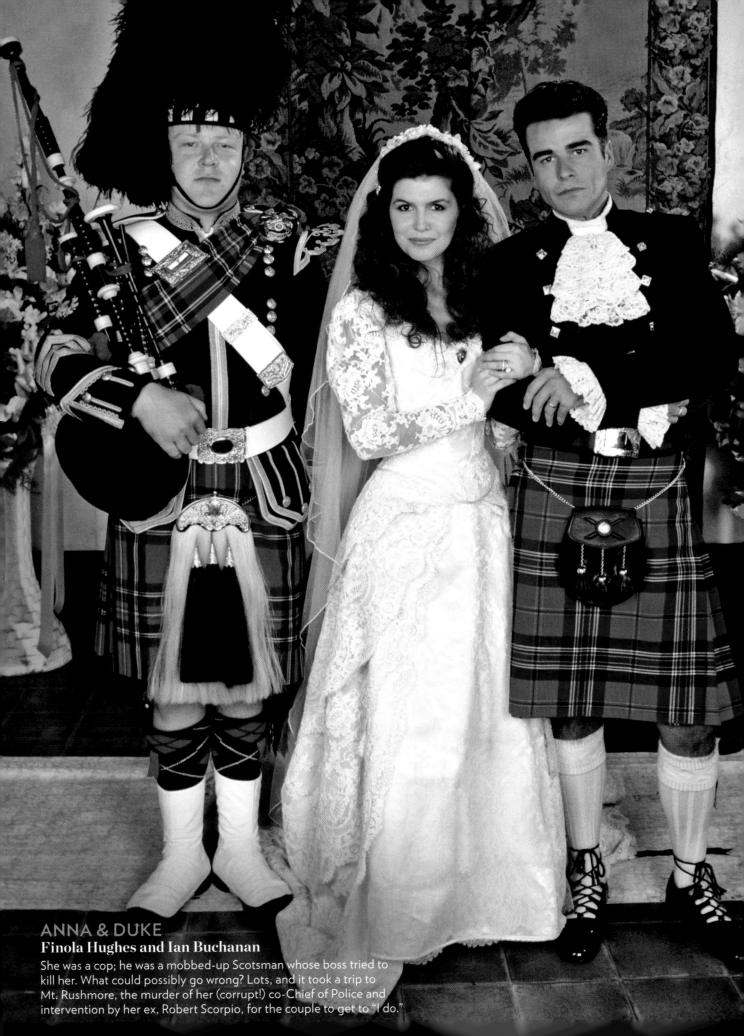

ANNA & DUKE
Finola Hughes and Ian Buchanan
She was a cop; he was a mobbed-up Scotsman whose boss tried to kill her. What could possibly go wrong? Lots, and it took a trip to Mt. Rushmore, the murder of her (corrupt!) co-Chief of Police and intervention by her ex, Robert Scorpio, for the couple to get to "I do."

A behind the scenes look at
two *Hospital* hotbeds: the nurses'
station and Kelly's Diner

Secrets from the Set

Cold Storage
It's a great place to be sick, but you wouldn't want to visit: the *GH* waiting room can accommodate two people, who share the tight space with props stockpiled just off camera.

GENERAL HOSPITAL
TENTH FLOOR

OPERATING ROOMS
POST OP / RECOVERY ROOMS
INTENSIVE CARE UNITS
TRIAGE

Always in bloom
When characters say it with flowers, fresh cut blooms are provided by daily deliveries. But those pictured here are forever—they're plastic.

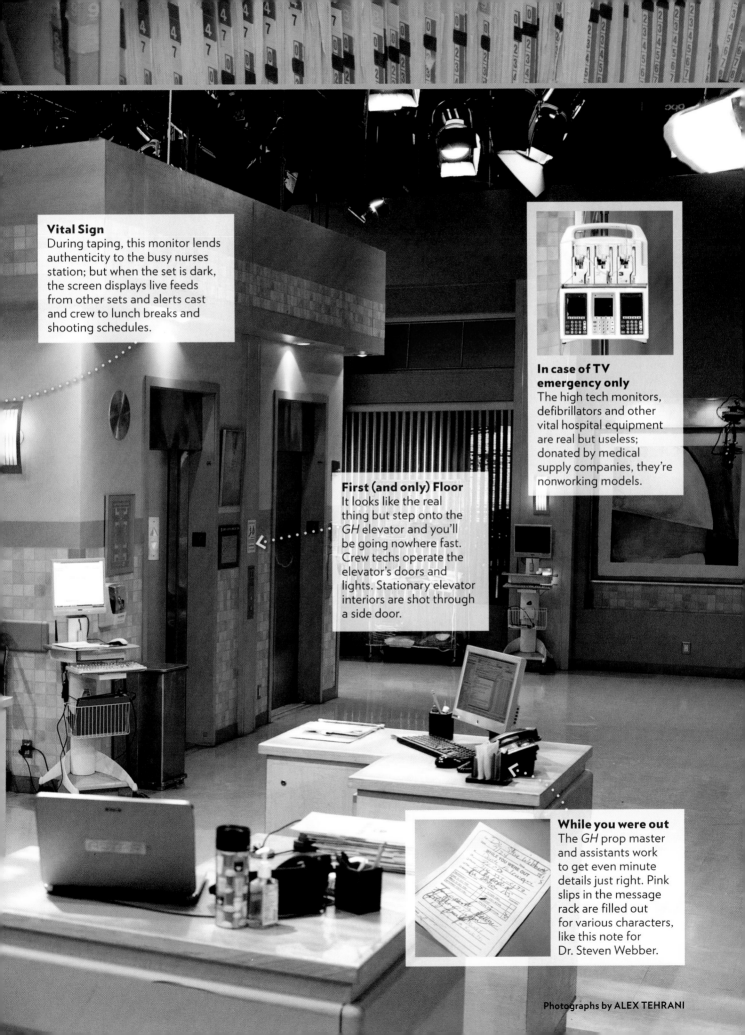

Vital Sign
During taping, this monitor lends authenticity to the busy nurses station; but when the set is dark, the screen displays live feeds from other sets and alerts cast and crew to lunch breaks and shooting schedules.

In case of TV emergency only
The high tech monitors, defibrillators and other vital hospital equipment are real but useless; donated by medical supply companies, they're nonworking models.

First (and only) Floor
It looks like the real thing but step onto the *GH* elevator and you'll be going nowhere fast. Crew techs operate the elevator's doors and lights. Stationary elevator interiors are shot through a side door.

While you were out
The *GH* prop master and assistants work to get even minute details just right. Pink slips in the message rack are filled out for various characters, like this note for Dr. Steven Webber.

Photographs by ALEX TEHRANI

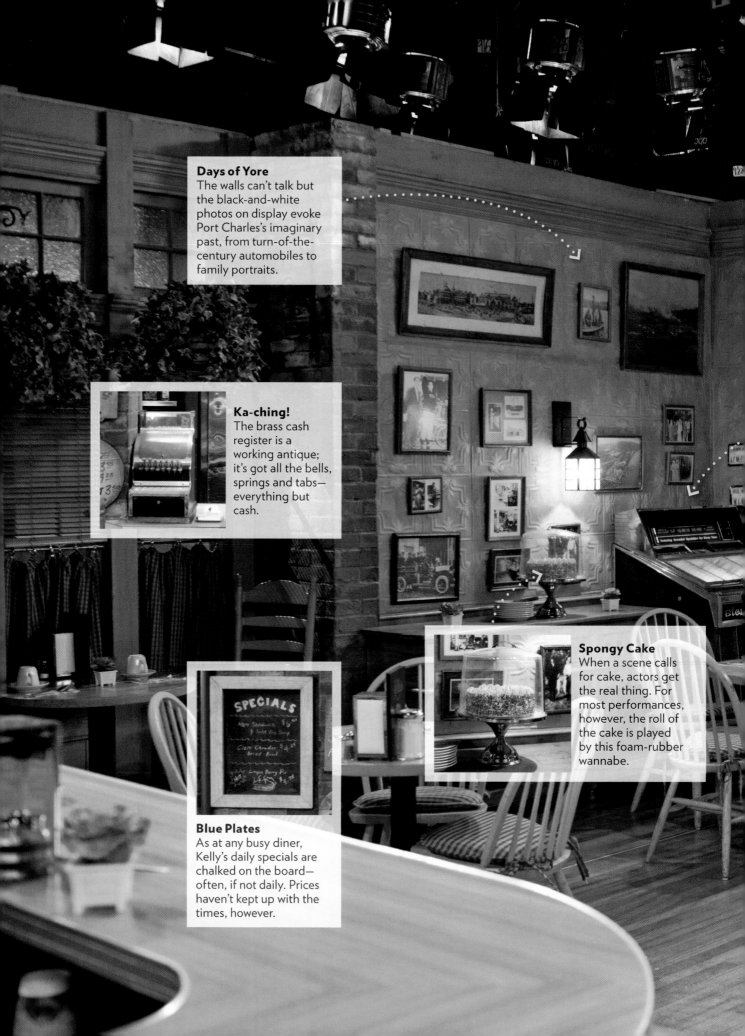

Days of Yore
The walls can't talk but the black-and-white photos on display evoke Port Charles's imaginary past, from turn-of-the-century automobiles to family portraits.

Ka-ching!
The brass cash register is a working antique; it's got all the bells, springs and tabs—everything but cash.

Spongy Cake
When a scene calls for cake, actors get the real thing. For most performances, however, the roll of the cake is played by this foam-rubber wannabe.

Blue Plates
As at any busy diner, Kelly's daily specials are chalked on the board—often, if not daily. Prices haven't kept up with the times, however.

SPECIALS

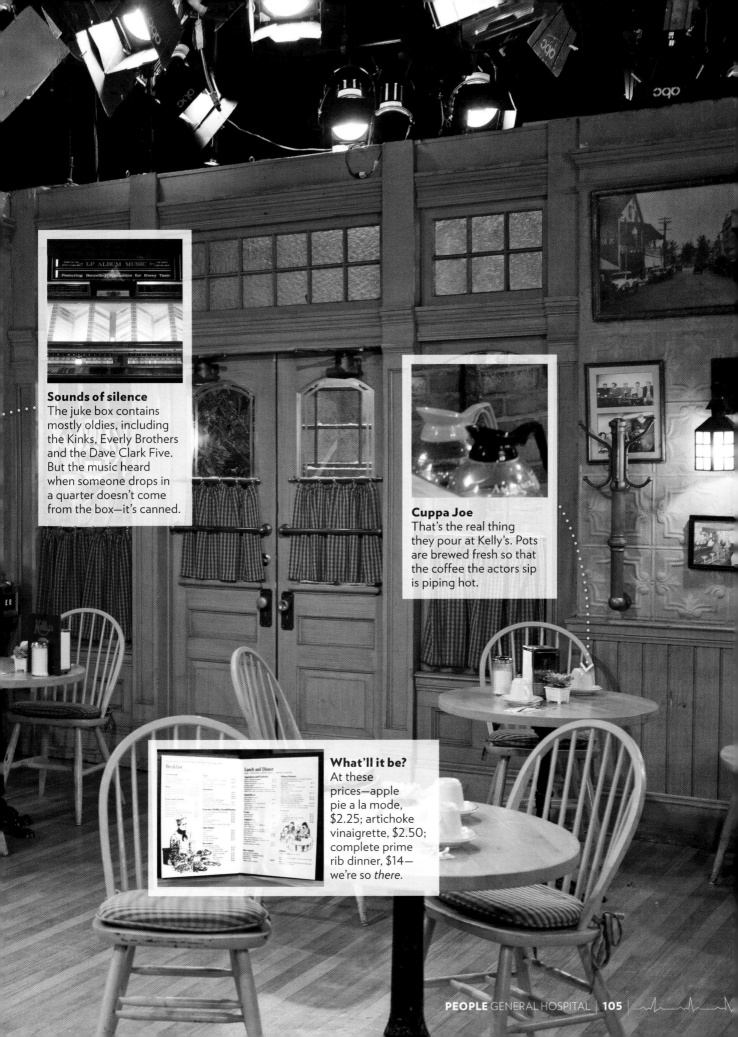

Sounds of silence
The juke box contains mostly oldies, including the Kinks, Everly Brothers and the Dave Clark Five. But the music heard when someone drops in a quarter doesn't come from the box—it's canned.

Cuppa Joe
That's the real thing they pour at Kelly's. Pots are brewed fresh so that the coffee the actors sip is piping hot.

What'll it be?
At these prices—apple pie a la mode, $2.25; artichoke vinaigrette, $2.50; complete prime rib dinner, $14— we're so *there*.

Details, details, details:
What you'd find on a backstage tour of the *GH* set

Scrapbook

IN YOUR DREAMS, SPINELLI!
When he imagined Lulu dancing with him at their wedding, she wore this white bridal gown.

STRIP TEASE
General Hospital got a plug from Sally Forth.

LUKE TO YOU
Anthony Geary keeps a reminder above his dressing room door.

WHO'S WHO
IDs for extras who play *Hospital* staffers are stored in the wardrobe department.

QUICK-CHANGE ARTISTS
Costumes are labeled by character, not actor names, on a rolling wardrobe rack.

SOAPS HEAVEN
The walls of an executive-office floor are lined with framed posters like this one of *GH* stars.

PIRATES' DEN
Prop masters and lighting technicians guard their turf.

GH WANTS YOU!
Lynn Herring displays *GH* take on "Keep Calm and Carry On" WWII slogan.

NO EXCUSES
Studio monitors keep time for all cast and crew.

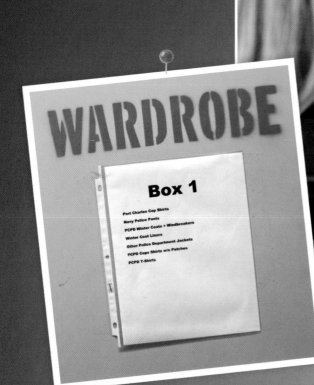

WARDROBE

Box 1

Port Charles Cop Shirts
Navy Police Pants
PCPD Winter Coats + Windbreakers
Winter Coat Liners
Other Police Department Jackets
PCPD Cops Shirts w/o Patches
PCPD T-Shirts

THE BIG PRIMP
Lindsey Morgan is readied for her scenes as Kristina Davis.

PORT CHARLES BLUES
P.C. police officers are dressed uniformly.

TOG TAGS
Each outfit is stored with wardrobe notes.

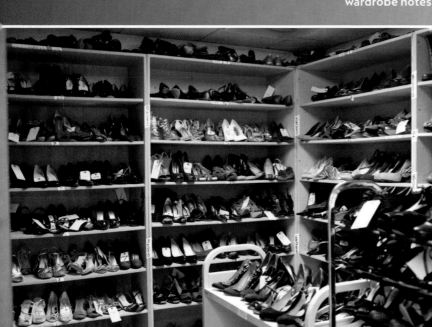

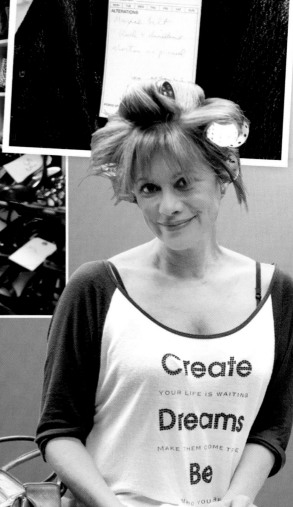

IMELDA MARCOS, EAT YOUR HEART OUT
An entire room in wardrobe is devoted to shoes, all tagged and organized by foot sizes.

ROLLER DERBY
Nancy Lee Grahn (Alexis) heads for the final lap of her preshow prep marathon.

BEEFCAKE PLATTER
A wardrobe staffer keeps im-pec-able notes.

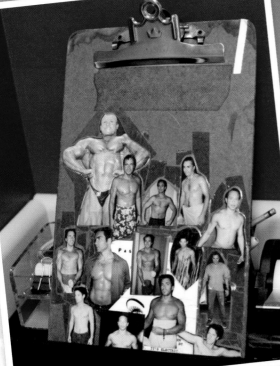

PUMPED UP
Someone thinks
Jason Quartermaine
is *muy macho.*

WHO WORE WHAT
Costume notes, sketches
and photos are archived.

COLD CASE
Backstage,
Anna's still
missing.

ANNA DEVANE LA
- MISSING -

Have You Seen
This Woman?
call 555-9317

HEADS UP
In the makeup room, stars face their competition.

They toiled on
General Hospital then
found even greater
fame later on

We Knew Them When

JACK WAGNER
Frisco Jones

Over a dozen years starting in 1983, he became a *GH* legend as the rocker-hunk-turned-special-agent (a song he recorded for the show, *All I Need*, became a real-life Top 10 hit). In 1995 Wagner left to indulge his dark side as *Melrose Place*'s alluring-but-evil Dr. Peter Burns.

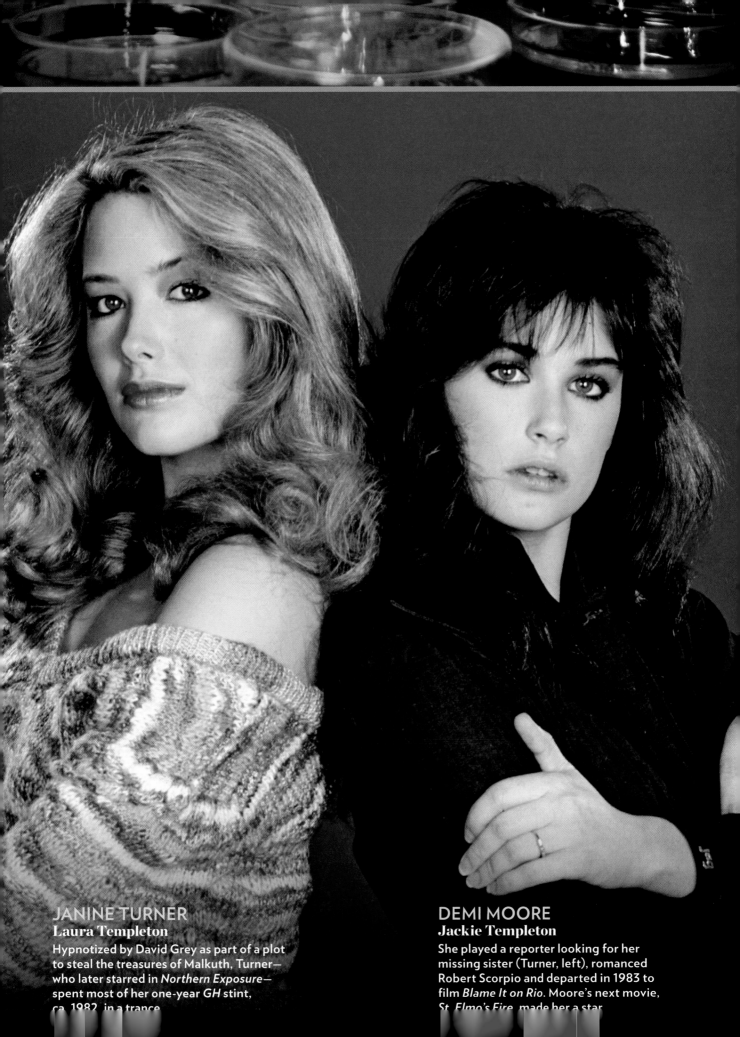

JANINE TURNER
Laura Templeton
Hypnotized by David Grey as part of a plot to steal the treasures of Malkuth, Turner—who later starred in *Northern Exposure*—spent most of her one-year *GH* stint, ca. 1982, in a trance.

DEMI MOORE
Jackie Templeton
She played a reporter looking for her missing sister (Turner, left), romanced Robert Scorpio and departed in 1983 to film *Blame It on Rio*. Moore's next movie, *St. Elmo's Fire*, made her a star.

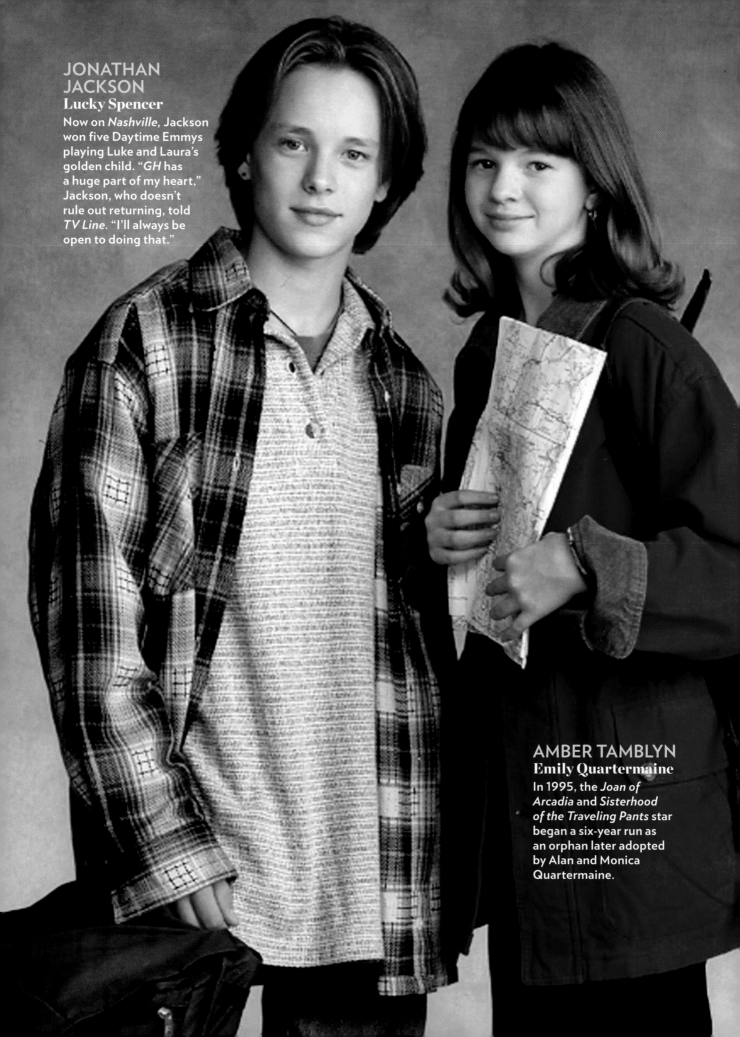

JONATHAN JACKSON
Lucky Spencer
Now on *Nashville*, Jackson won five Daytime Emmys playing Luke and Laura's golden child. "*GH* has a huge part of my heart," Jackson, who doesn't rule out returning, told *TV Line*. "I'll always be open to doing that."

AMBER TAMBLYN
Emily Quartermaine
In 1995, the *Joan of Arcadia* and *Sisterhood of the Traveling Pants* star began a six-year run as an orphan later adopted by Alan and Monica Quartermaine.

TIA CARRERE
Jade Soong Chung
From 1985 to 1987, she played the granddaughter of evil mastermind Wu.

MARK HAMILL
Kent Murray
Long ago—1972 to 1973, to be precise—and in what must seem like a galaxy far, far away, the *Star Wars* star played the troubled orphaned nephew of Nurse Jessie Brewer.

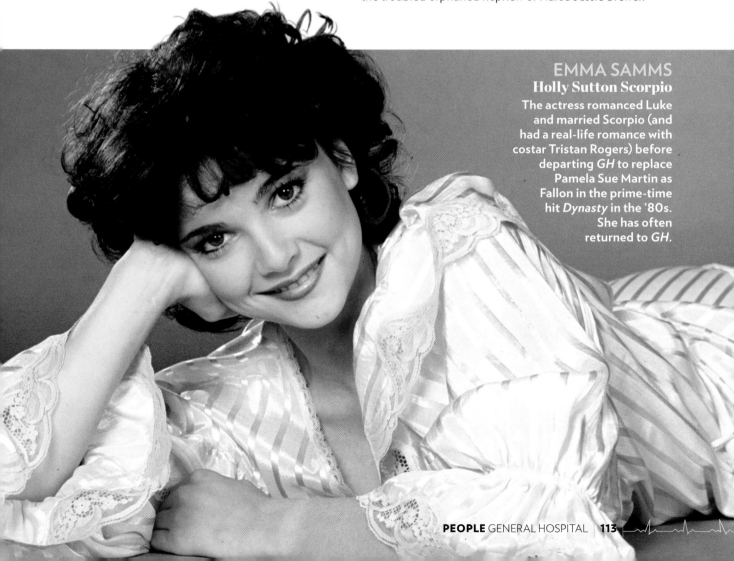

EMMA SAMMS
Holly Sutton Scorpio
The actress romanced Luke and married Scorpio (and had a real-life romance with costar Tristan Rogers) before departing *GH* to replace Pamela Sue Martin as Fallon in the prime-time hit *Dynasty* in the '80s. She has often returned to *GH*.

Cameos

Celebrity fans often checked in for brief stays in the *Hospital*

RICHARD SIMMONS
Himself

In the late '70s and early '80s, before anyone had heard of *Sweatin' to the Oldies*, the exercise fanatic was a frequent *GH* guest, leading classes in the disco. "Gloria Monty was stricter than any Catholic nun who taught me in school," Simmons has said. *GH* exposure helped make his book *Never-Say-Diet* a huge hit.

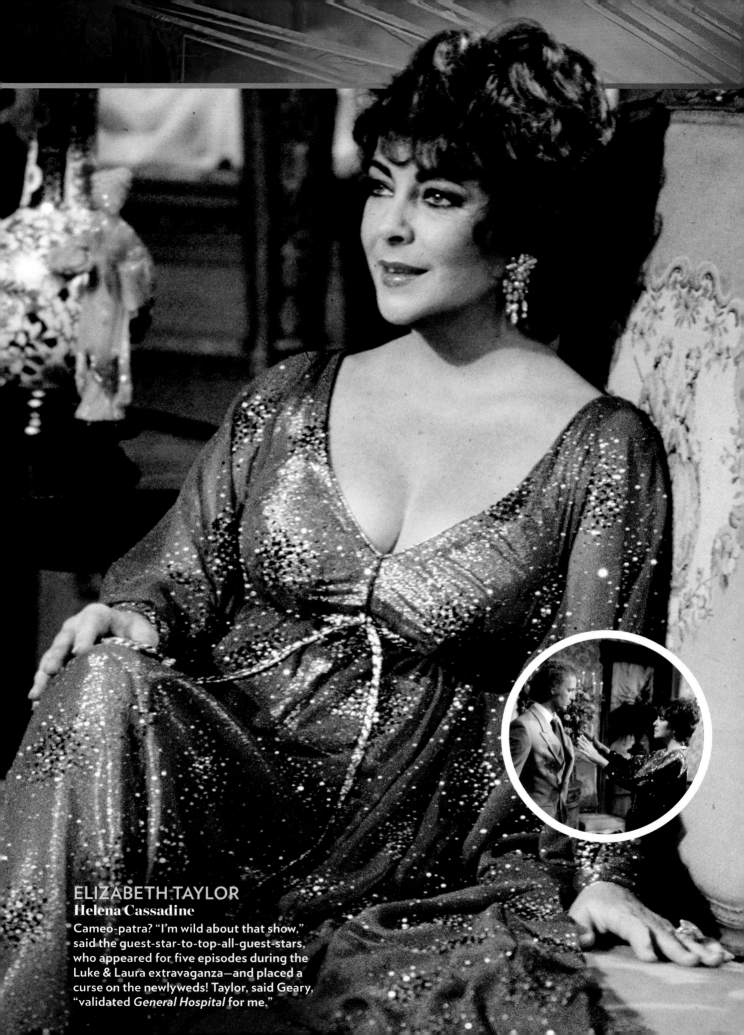

ELIZABETH TAYLOR
Helena Cassadine

Cameo-patra? "I'm wild about that show," said the guest-star-to-top-all-guest-stars, who appeared for five episodes during the Luke & Laura extravaganza—and placed a curse on the newlyweds! Taylor, said Geary, "validated *General Hospital* for me."

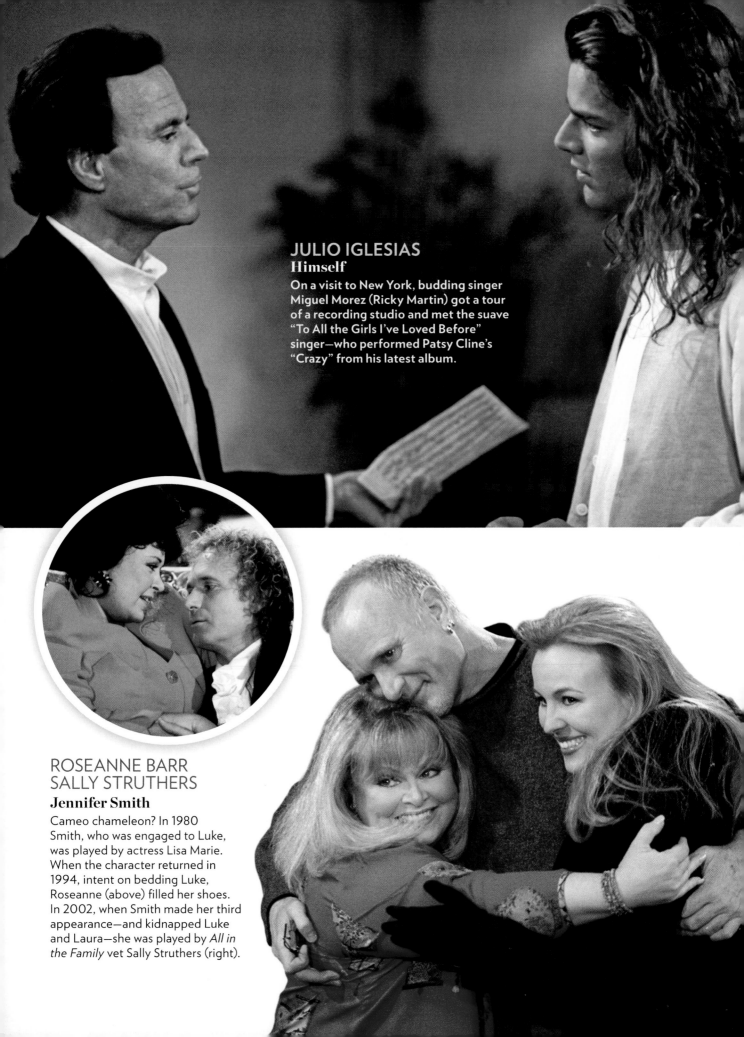

JULIO IGLESIAS
Himself

On a visit to New York, budding singer Miguel Morez (Ricky Martin) got a tour of a recording studio and met the suave "To All the Girls I've Loved Before" singer—who performed Patsy Cline's "Crazy" from his latest album.

ROSEANNE BARR
SALLY STRUTHERS
Jennifer Smith

Cameo chameleon? In 1980 Smith, who was engaged to Luke, was played by actress Lisa Marie. When the character returned in 1994, intent on bedding Luke, Roseanne (above) filled her shoes. In 2002, when Smith made her third appearance—and kidnapped Luke and Laura—she was played by *All in the Family* vet Sally Struthers (right).

DR. IRENE KASSORLA
Herself

The L.A.based psychologist and sex therapist, dubbed by Merv Griffin the "shrink to the stars," popped-in in the '80s to host group therapy sessions for *GH* characters—who were inspired, no doubt, by her recent bestseller *Nice Girls Do*.

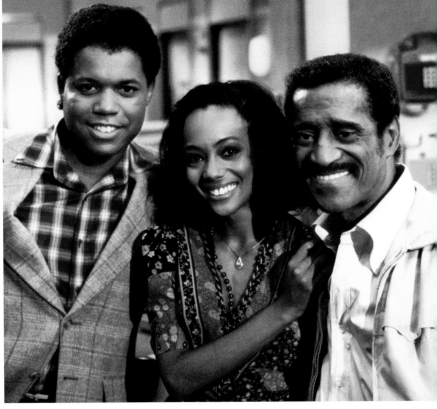

SAMMY DAVIS JR.
Eddie Phillips

By the time he appeared on *GH* for five days in 1982—playing a terminally ill dad trying to make peace with his son—Davis was a soap vet: Earlier the song-and-dance man had appeared on *One Life to Live* and *Love of Life*.

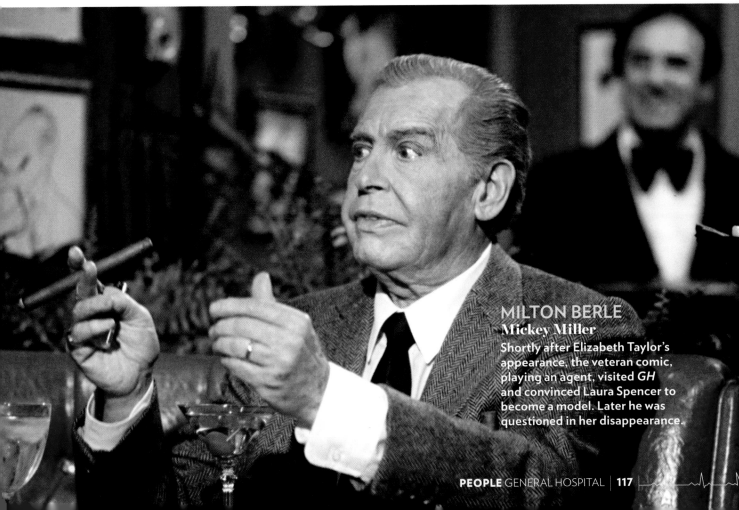

MILTON BERLE
Mickey Miller

Shortly after Elizabeth Taylor's appearance, the veteran comic, playing an agent, visited *GH* and convinced Laura Spencer to become a model. Later he was questioned in her disappearance.

Acting, making pies,
selling real estate: Catching up
with former *GH* stars after
they checked out of *Hospital*

Where Are They Now?

LINDA DONA
Nancy Eckert

Surprised by a sudden screen test for the role of Bill Eckert's duplicitous ex-wife, Dona had no time to memorize dialogue. So she mostly made it up. "Gloria Monty said, 'Honey, that's very good, but whose lines were you reading?' I said, 'My own, dammit!' I had the best time playing Nancy." Dona later lived in Europe, then returned to L.A.; in 2009, she played a nasty warden in gals-in-the-slammer film *Sugar Boxx*.

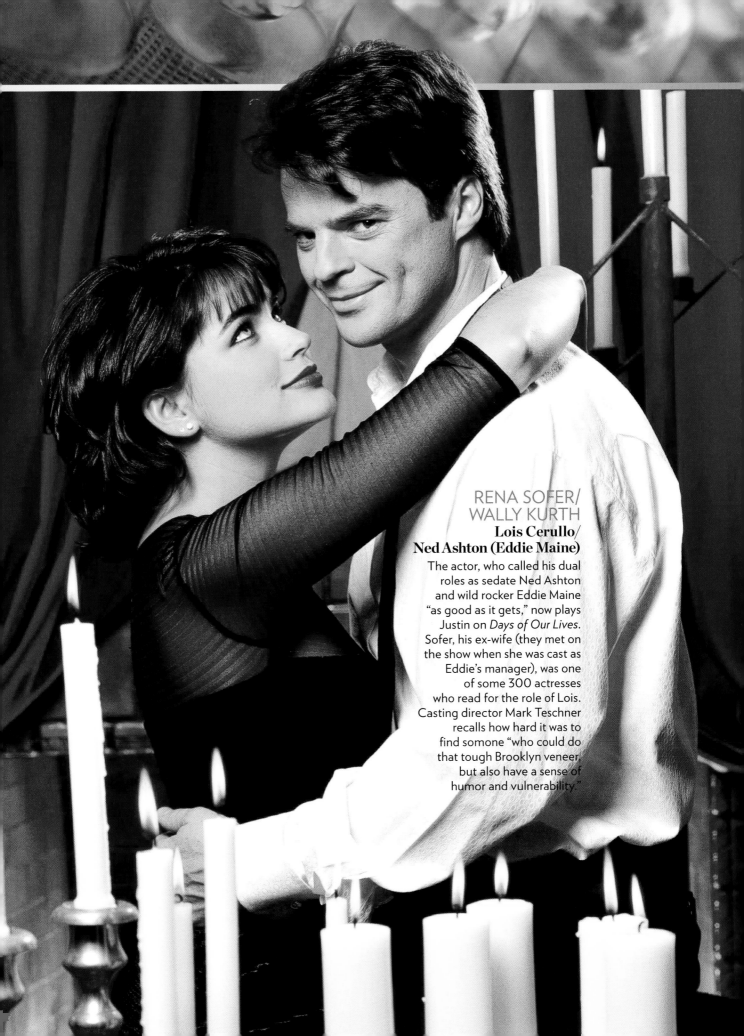

RENA SOFER/
WALLY KURTH
Lois Cerullo/
Ned Ashton (Eddie Maine)

The actor, who called his dual
roles as sedate Ned Ashton
and wild rocker Eddie Maine
"as good as it gets," now plays
Justin on *Days of Our Lives*.
Sofer, his ex-wife (they met on
the show when she was cast as
Eddie's manager), was one
of some 300 actresses
who read for the role of Lois.
Casting director Mark Teschner
recalls how hard it was to
find somone "who could do
that tough Brooklyn veneer,
but also have a sense of
humor and vulnerability."

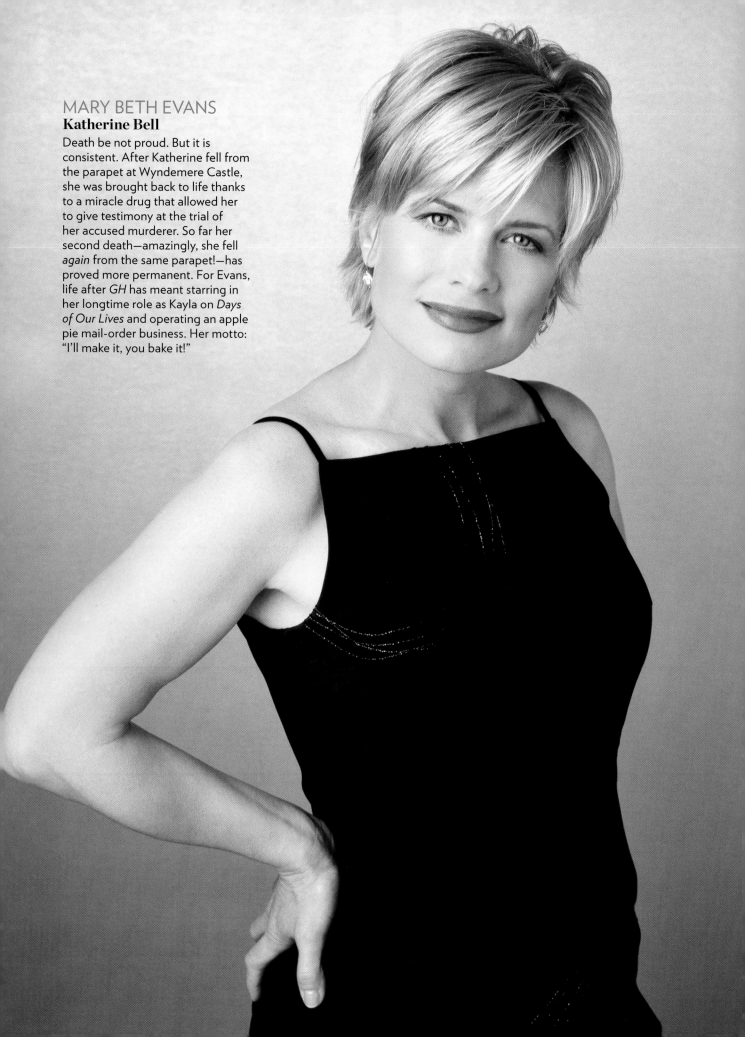

MARY BETH EVANS
Katherine Bell

Death be not proud. But it is consistent. After Katherine fell from the parapet at Wyndemere Castle, she was brought back to life thanks to a miracle drug that allowed her to give testimony at the trial of her accused murderer. So far her second death—amazingly, she fell *again* from the same parapet!—has proved more permanent. For Evans, life after *GH* has meant starring in her longtime role as Kayla on *Days of Our Lives* and operating an apple pie mail-order business. Her motto: "I'll make it, you bake it!"

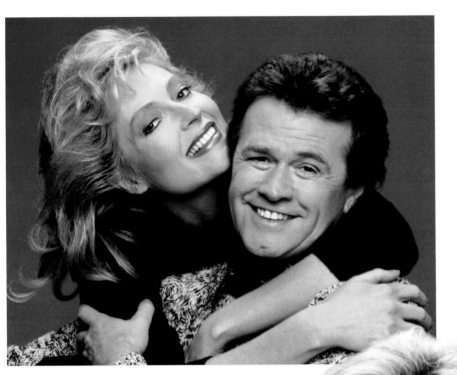

SHARON WYATT/ JOHN REILLY
Tiffany Hill/Sean Donely

After the B-movie actress and bad guy turned police commissioner wed, they left *GH* in 1995. They were reunited on *Passions* and again in 2008 on *Night Shift*, a short-lived SOAPnet *GH* spin-off. Reilly also played Jennifer Garth's dad on *Beverly Hills, 90210*. Today he appears on the Web series *The Bay* and with wife Liz runs a baby boutique called Flicka. Wyatt's soap career was cut short by a real hospital drama: She has endured extensive surgeries to treat bone disease.

SARAH JOY BROWN
Carly Roberts/ Claudia Zacchara

Brown nailed not one but two big *GH* roles: Carly, the long-lost daughter Bobbie Spencer had during her hooker days, and Claudia, a damaged mafia princess. "Carly was the flawed everywoman, whereas Claudia was a very specific flawed woman," says Brown, who dyed her hair dark for the latter role. She now does guest spots on shows like *CSI* and speaks out about celiac disease, which she has. "I want to help people get diagnosed and point them in the right direction," she says.

LILLY MELGAR
Lily Corinthos

Her star-crossed character died tragically when a car bomb, planted by her father to blow up her husband, killed her instead. "I was on a plane, and a stewardess told me that she chose to take a week off from work because she was so devastated by Lily's death," recalls Melgar, who's now starring on *The Bay* as feisty Janice Ramos. Herself an over-the-top *GH* fan, Melgar remembers telling friends in junior high that she was destined to star on the show. Later, after seeing Maurice Benard costar in 1991's *Lucy and Desi: Before the Laughter*, she told her mom, "I'm going to work with that man!" When both fantasies came true and her Lily married Benard's Sonny, says Melgar, "I remember being on set, exhaling and saying, 'Yep—I'm here!'"

DAVID WALLACE
Dr. Tom Hardy

Look familiar? That's because Wallace has done time on *Days of Our Lives* as well as *GH*. He and former *Days* cast mate Lisa Trusel have four children. Currently Wallace's career buzz might be caused by a short: He owns an electrical business in Seal Beach, Calif.

BRIAN PATRICK CLARKE
Grant Andrews/Grant Putnam

"Trust me, baby. Trust me!" Thus Gloria Monty reassured Clarke that his character was not the wimpy, whipped hubby he first appeared to be. "I couldn't figure out why Grant [Andrews] was acting so milquetoast," recalls Clarke, the *Eight Is Enough* alum who is married to Olympic gymnast Kathy Johnson. Monty's plot twist: Grant was really a Russian spy who covered his tracks by cowering before his wife.

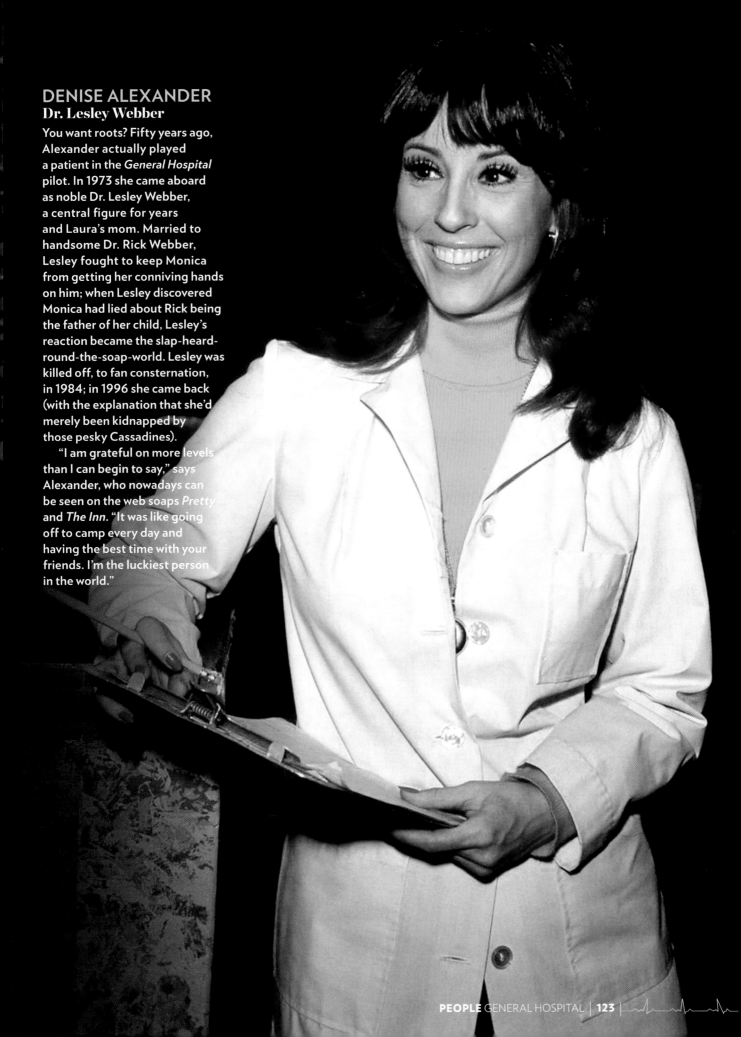

DENISE ALEXANDER
Dr. Lesley Webber

You want roots? Fifty years ago, Alexander actually played a patient in the *General Hospital* pilot. In 1973 she came aboard as noble Dr. Lesley Webber, a central figure for years and Laura's mom. Married to handsome Dr. Rick Webber, Lesley fought to keep Monica from getting her conniving hands on him; when Lesley discovered Monica had lied about Rick being the father of her child, Lesley's reaction became the slap-heard-round-the-soap-world. Lesley was killed off, to fan consternation, in 1984; in 1996 she came back (with the explanation that she'd merely been kidnapped by those pesky Cassadines).

"I am grateful on more levels than I can begin to say," says Alexander, who nowadays can be seen on the web soaps *Pretty* and *The Inn*. "It was like going off to camp every day and having the best time with your friends. I'm the luckiest person in the world."

JUDITH CHAPMAN
Ginny Blake

Bad enough that she gave up her son for adoption. But when Ginny Blake's villainy was rewarded with marriage to Rick, the man who adopted her own little Mike—after his beloved, *GH* viewer favorite Lesley Webber, was killed off—fans let their ill feelings be known.

"For the first few weeks, fans were outside the studio holding signs saying 'Let Lesley Live!'" recalls Chapman. "When they stopped throwing eggs at my car, I thought, 'Okay, I'm making progress.'"

Now casting daytime shadows as Gloria Bardwell on *The Young and the Restless*, Chapman also directs stage productions in Palm Springs and performs *Vivien*, her one-woman show about Vivien Leigh.

At a *GH* cast reunion, she ran into David Mendenhall, who played Mike, the son she abandoned and later tried to reclaim. "He was over 6 feet tall and had an earring," says Chapman. "I was stunned! My baby from *General Hospital* was all grown up— and gorgeous!"

JACK WAGNER
Frisco Jones

Anthony Geary had just left; enter, with the job of rewarming the hearts of female fans, Wagner as Frisco Jones, a hot new singer for the band Blackie and the Riff Raff. Singing on the show gave him a hit ("All I Need") and a brief recording career. And Wagner and his onscreen love, actress Kristina Malandro, fell in love, wed and had two children before divorcing in 2006. After *GH* he landed on *Santa Barbara*, *Melrose Place* and *The Bold and the Beautiful*. More recently, "I did *Dancing with the Stars*, *Hot in Cleveland* and an episode of *Castle*," he says. "I'm kind of enjoying it and seeing what comes next."

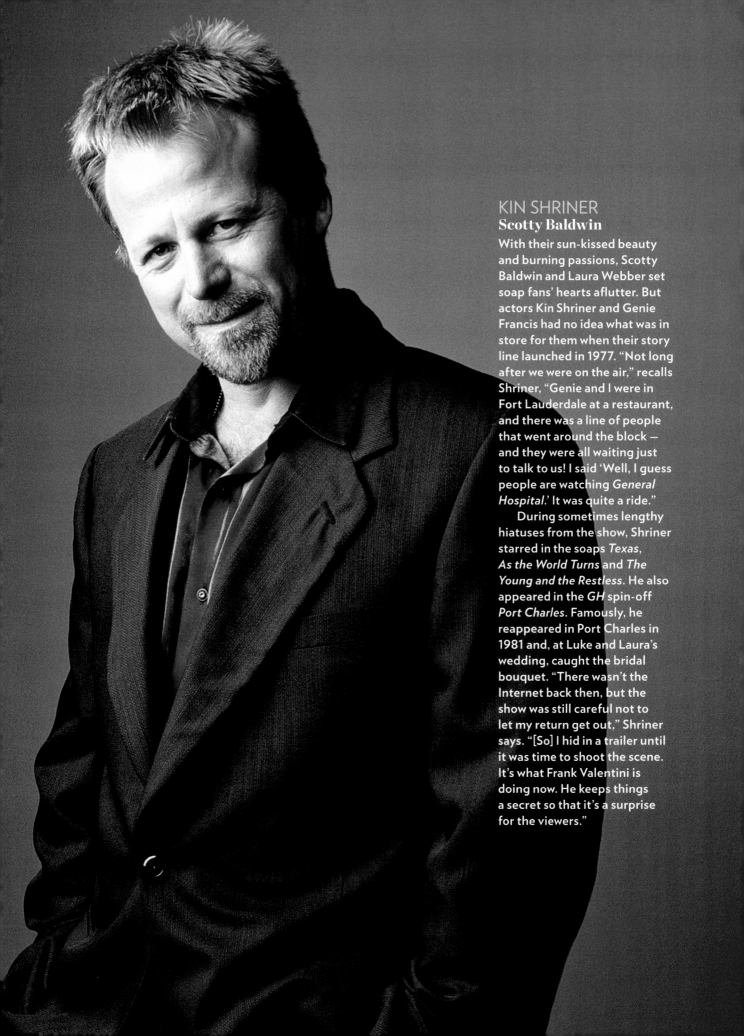

KIN SHRINER
Scotty Baldwin

With their sun-kissed beauty and burning passions, Scotty Baldwin and Laura Webber set soap fans' hearts aflutter. But actors Kin Shriner and Genie Francis had no idea what was in store for them when their story line launched in 1977. "Not long after we were on the air," recalls Shriner, "Genie and I were in Fort Lauderdale at a restaurant, and there was a line of people that went around the block — and they were all waiting just to talk to us! I said 'Well, I guess people are watching *General Hospital*.' It was quite a ride."

During sometimes lengthy hiatuses from the show, Shriner starred in the soaps *Texas*, *As the World Turns* and *The Young and the Restless*. He also appeared in the *GH* spin-off *Port Charles*. Famously, he reappeared in Port Charles in 1981 and, at Luke and Laura's wedding, caught the bridal bouquet. "There wasn't the Internet back then, but the show was still careful not to let my return get out," Shriner says. "[So] I hid in a trailer until it was time to shoot the scene. It's what Frank Valentini is doing now. He keeps things a secret so that it's a surprise for the viewers."

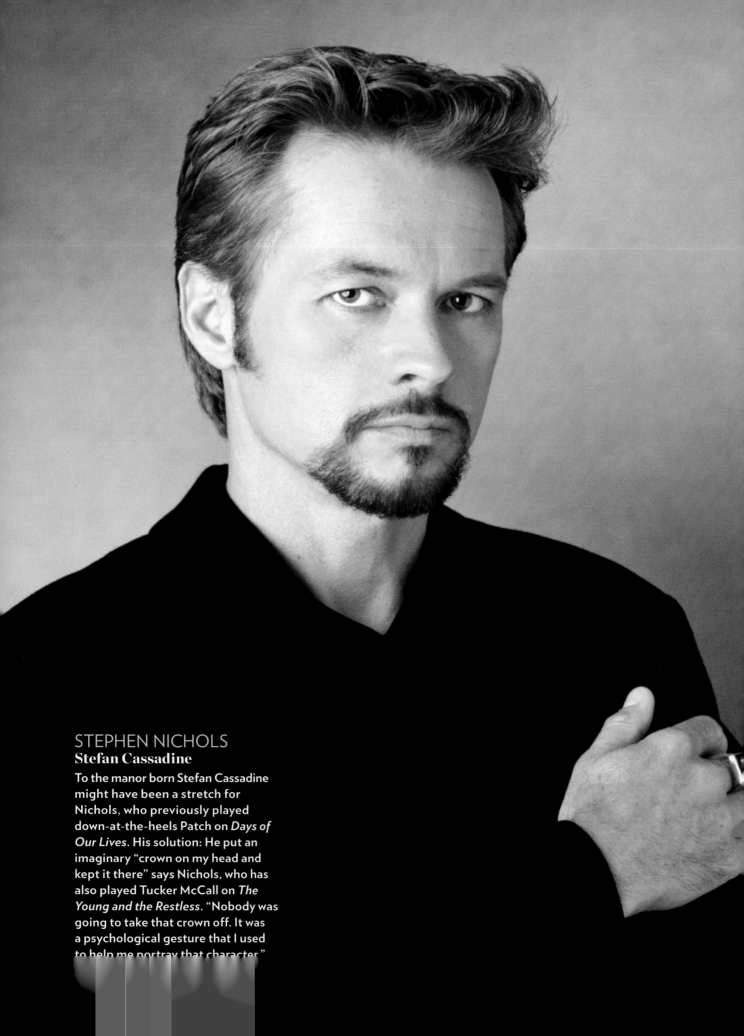

STEPHEN NICHOLS
Stefan Cassadine

To the manor born Stefan Cassadine might have been a stretch for Nichols, who previously played down-at-the-heels Patch on *Days of Our Lives*. His solution: He put an imaginary "crown on my head and kept it there" says Nichols, who has also played Tucker McCall on *The Young and the Restless*. "Nobody was going to take that crown off. It was a psychological gesture that I used to help me portray that character."

PHILIP TANZINI
Jeremy Hewitt Logan
As the orphan and Typhoid Mary who carried the dread Lassa Fever that threatened Port Charles in 1978, Tanzini began an acting career that led to *21 Jump Street* and *L.A. Law*. Still, a highlight came at 15, says Tanzini (now an off-camera voice actor who played a deejay on *Two and a Half Men*), when 19-year-old Demi Moore kissed him on the lips.

SUSAN BROWN
Dr. Gail Baldwin
On-the-job training? Between stints as the hospital's resident shrink, a role she has played off and on since 1977, the soap veteran took her talents to another living psychology lab, the White House, playing first ladies Pat Nixon (*The Final Days*) and Nancy Reagan (*Without Warning: The James Brady Story*).

SUSAN PRATT
Anne Logan
Her character was "the oldest living virgin on daytime television," said Pratt, who appeared on *Guiding Light* and *All My Children* and is now a real estate agent in New York City.

Editor Cutler Durkee **Design Director** Andrea Dunham **Photo Director** Chris Dougherty **Photo Editor** C. Tiffany Lee-Ramos **Art Director** Cynthia Rhett
Designer Joan Dorney **Writer** Steve Dougherty **Correspondents** Michael Maloney, Robin Micheli **Writer/Reporter** Ellen Shapiro **Reporter** Mary Hart
Copy Editor Will Becker **Scanners** Brien Foy, Salvador Lopez, Stephen Pabarue **Group Imaging Director** Francis Fitzgerald
Imaging Manager Rob Roszkowski **Imaging Production Managers** Charles Guardino, Romeo Cifelli, Jeffrey Ingledue

Special thanks: Céline Wojtala, David Barbee, Jane Bealer, Patricia Clark, Margery Frohlinger, Suzy Im, Ean Sheehy, Patrick Yang

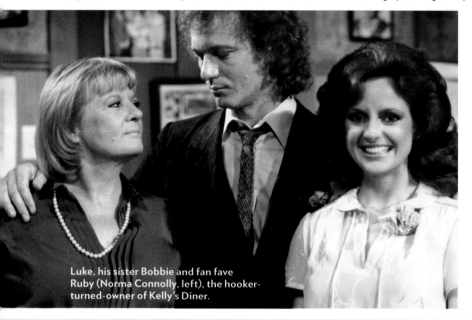

Luke, his sister Bobbie and fan fave Ruby (Norma Connolly, left), the hooker-turned-owner of Kelly's Diner.

TIME HOME ENTERTAINMENT
Publisher Jim Childs
Vice President, Business Development & Strategy Steven Sandonato
Executive Director, Marketing Services Carol Pittard
Executive Director, Retail & Special Sales Tom Mifsud
Executive Publishing Director Joy Butts
Director, Bookazine Development & Marketing Laura Adam
Finance Director Glenn Buonocore
Associate Publishing Director Megan Pearlman
Assistant General Counsel Helen Wan
Assistant Director, Special Sales Ilene Schreider
Book Production Manager Suzanne Janso
Design & Prepress Manager Anne-Michelle Gallero
Brand Manager Michela Wilde
Associate Prepress Manager Alex Voznesenskiy
Associate Brand Manager Isata Yansaneh

Editorial Director Stephen Koepp
Editorial Operations Director Michael Q. Bullerdick

Special thanks:
Katherine Barnet, Jeremy Biloon, Susan Chodakiewicz, Rose Cirrincione, Lauren Hall Clark, Jacqueline Fitzgerald, Christine Font, Jenna Goldberg, Hillary Hirsch, David Kahn, Amy Mangus, Robert Marasco, Kimberly Marshall, Amy Migliaccio, Nina Mistry, Dave Rozzelle, Ricardo Santiago, Adriana Tierno, Vanessa Wu

FRONT COVER
Clockwise from top right: Jonathan Exley/Contour by Getty Images; Bob D'Amico/ABC Photo Archives; Hope North/Corbis; Bob D'Amico/ABC Photo Archives; Emily Shur

CONTENTS
2 Erik Hein/ABC Photo Archives; **3** Clockwise from top left: Erik Hein/ABC/Getty Images; ABC Photo Archives; Emily Shur; Craig Sjodin/ABC/Getty Images

LUKE AND LAURA
6-7 Erik Hein/ABC Photo Archives; **11** Craig Sjodin/ABC Photo Archives; **12-13** Alison Dyer; **15** John Paschal/JPI

THE 1970'S
25 Clockwise from top: ABC Photo Archives/Getty Images(2); Wayne Williams/ABC Photo Archives; **26-27** ABC Photo Archives/Getty Images(3)

THE 1980'S
32 Top: ABC Photo Archives/Getty Images; **33** From top: Craig Sjodin/ABC Photo Archives(2); Jerry Fitzgerald/ABC Photo Archives; **34** Jerry Fitzgerald/ABC Photo Archives; **35** Top: Craig Sjodin/ABC Photo Archives; **36** From left: Erik Hein/ABC Photo Archives; Craig Sjodin/ABC Photo Archives; **37** Bob D'Amico/ABC Photo Archives

THE 1990'S
38-39 Craig Sjodin/ABC Photo Archives; **40** From top: Jerry Fitzgerald/ABC Photo Archives; Craig Sjodin/ABC Photo Archives; **41** Clockwise from top left: Cathy Blaivas/ABC Photo Archives; Jim Ober/ABC Photo Archives; Michael Yarish/ABC Photo Archives; Craig Sjodin/ABC Photo Archives; **42-43** Craig Sjodin/ABC Photo Archives(2); **44** Jonathan Exley/Contour by Getty Images; **45** Clockwise from top: Craig Sjodin/ABC Photo Archives; Timothy White/ABC Photo Archives; Jonathan Exley/Contour by Getty Images

THE 2000'S
46-47 From left: Sean Smith/JPI; Scott Garfield/ABC Photo Archives; **48** From top: Jeffrey Mayer/ABC Photo Archives; Scott Garfield/ABC Photo Archives; Tom Queally/ABC Photo Archives; Carol Kaelson/ABC Photo Archives; **49** Clockwise from top: Adam Larkey/ABC Photo Archives; Rick Rowell/ABC Photo Archives; Patrick Wymore/ABC Photo Archives; Paul Skipper/JPI; Ron Tom/ABC Photo Archives; **50** Ron Tom/ABC Photo Archives; **51** Clockwise from right: Paul Skipper/JPI; Carol Kaelson/ABC Photo Archives; Michael Yarish/ABC/Getty Images; Adam Larkey/ABC Photo Archives **52** Ron Tom/ABC/Getty Images; **53** Clockwise from top right: Patrick Wymore/ABC/Getty Images(2); Ron Tom/ABC Photo Archives(2)

THE CAST
54-79 Photographs by Emily Shur; Hair: Anzhela Adzhiyan, Jennifer Petrovich, Lauren Poole; Makeup: Angela Ackley, Donna Messina Armogida, Tamara Papirian; Costume Designer: Shawn Reeves; Wardrobe: Sara Anderson; Prop Master: Robert Markham; General Hospital Production Coordinators: Jillian Dedote, Chandler Hayes, Lauri L.Hogan; **61, 67, 70** Photographs by Alison Dyer; **66** Photograph by Alex Tehrani

HOT GUYS
81 Maureen Donaldson/Getty Images; **82** Jonathan Exley/Contour by Getty Images; **83** From top left: ABC Photo Archives/Getty Images; John Paschal/JPI; **84** Hope North/Corbis; **85** Clockwise from top left: ABC Photo Archives/Getty Images; Steve Schapiro/Corbis; Barry King/Wireimage; **86** Clockwise from top left: Scott Weiner/Retna/Corbis; ABC Photo Archives; ABC Photo Archives/Getty Images; **87** Barry King/Contour by Getty Images

VILLAINS
88-89 Bob D'Amico/ABC Photo Archives; **90** Bottom right: Ron Tom/Getty Images; **91** Clockwise from top left: Sean Smith/JPI;

Adam Larkey/ABC/Getty Images; Lisa Rose/ABC/Getty Images; **92** Top left: Ron Tom/ABC Photo Archives; Bottom: Erik Hein/ABC/Getty Images; **93** Rick Rowell/ABC/Getty Images

WEDDINGS
94-95 Ron Tom/ABC/Getty Images; **97** Rick Rowell/ABC/Getty Images; **98** Left: Rick Rowell/ABC/Getty Images; Bottom right: Erik Hein/ABC Photo Archives; **99** Left: Bob D'Amico/ABC Photo Archives

SECRETS FROM THE SET
102-109 Photographs by Alex Tehrani

WE KNEW THEM WHEN
111 Erik Hein/ABC/Getty Images; **112** Craig Sjodin/ABC Photo Archives; **113** Top right and bottom: ABC Photo Archives/Getty Images(2)

CAMEOS
116 Middle: Michael Yarish/ABC Photo Archives; Bottom: Scott Garfield/ABC Photo Archives

WHERE ARE THEY NOW
118 Craig Sjodin/ABC Photo Archives; **119** Jonathan Exley/Contour by Getty Images; **120** Andrew Eccles/ABC Photo Archives; **121** From top: Bob D'Amico/ABC Photo Archives; ABC/Getty Images; **122** Left & top: Craig Sjodin/ABC Photo Archives(2); **125** Andrew Eccles/ABC Photo Archives; **126** Craig Sjodin/ABC Photo Archives; **127** Bottom right: ABC Photo Archives/Getty Images

All Other Photos: ABC Photo Archives
All Stock Photos: Shutterstock

BACK COVER
Clockwise from bottom left: Emily Shur; Craig Sjodin/ABC Photo Archives; Emily Shur; ABC Photo Archives(2)

ISBN 10: 1-61893-059-1; **ISBN 13:** 978-1-61893-059-0; Library of Congress Control Number: 2012953237